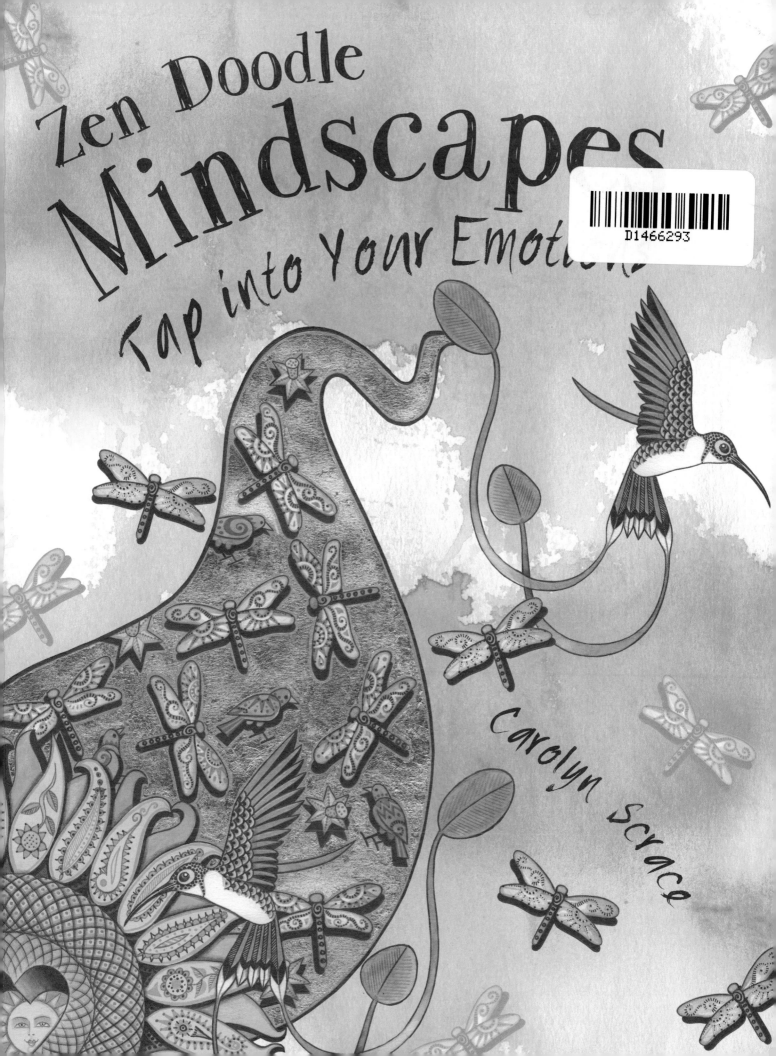

Zen Doodle
Mindscapes
Tap into Your Emotions

Carolyn Scrace

First edition for North America and
its territories published in 2017 by
Barron's Educational Series, Inc.

First published in Great Britain in 2017 by Book House,
an imprint of The Salariya Book Company Ltd.

© The Salariya Book Company Limited, MMXVII
25 Marlborough Place, Brighton BN1 1UB

All inquiries should be addressed to:
Barron's Educational Series, Inc.
250 Wireless Boulevard
Hauppauge, New York 11788
www.barronseduc.com

Library of Congress Control Number: 2016956521

ISBN: 978-1-4380-0982-7

Printed in China
9 8 7 6 5 4 3 2 1

Zen Doodle Mindscapes

Tap into Your Emotions

Carolyn Scrace

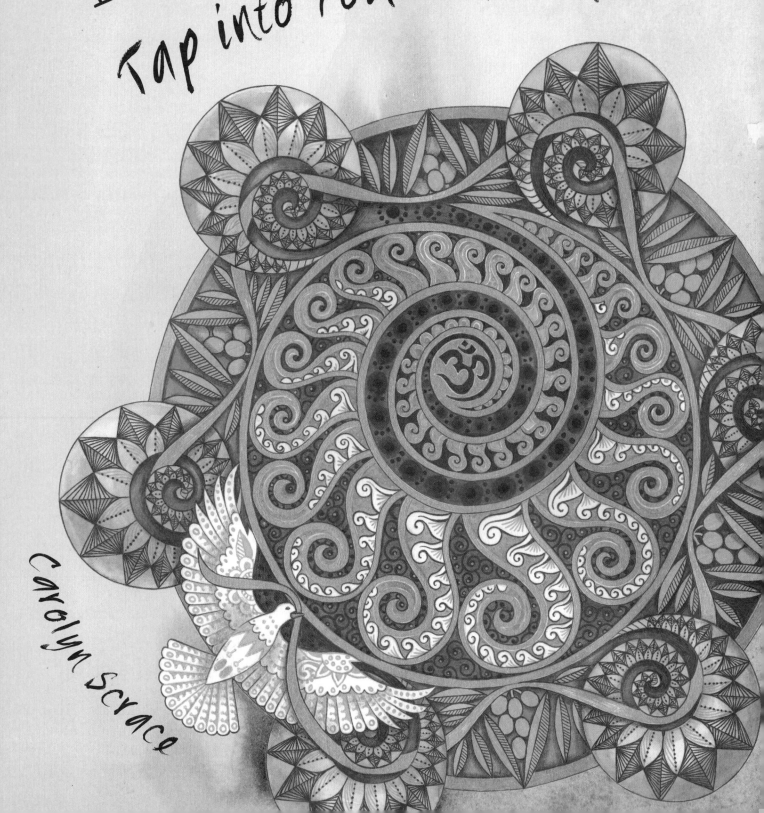

Contents

Introduction

"Every artist dips his brush in his own soul, and paints his own nature into his pictures."

Henry Ward Beecher

Introduction to Zen Doodling

Pattern Building

Zen Doodling is fun! It uses the simple technique of pattern building to create stunning pieces of artwork. Zen Doodling is a creative way of releasing the subconscious. It encourages mindfulness and meditation. The process of doodling repetitive patterns frees the mind, allowing it to reveal and express inner emotions.

Artistic Techniques

This book explores a variety of simple artistic techniques that include collage, printmaking, and indenting. It has easy to follow step-by-step instructions and artists' tips to encourage you to experiment creatively.

Creative Confidence

The fun activities in this book are guaranteed to excite your imagination and build your creative confidence. Zen Doodling can be done anywhere and at any time. No special materials or equipment are necessary. Simply relax and let your emotional journey begin.

Creating patterns goes back to ancient times and derives from many different cultures around the world, including Greek, Roman, Celtic, Native American, and Maori.

" A work of art which did not begin in emotion is not art."

Paul Cezanne

Emotions in Art
Cathartic Experience

Zen Doodle Mindscapes explores the relationship between feelings and art. Each chapter encapsulates a personal journey through a different set of emotions using imagery that reflects specific sentiments. Zen Doodling can be a very cathartic experience. It allows you to express your inner feelings and explore the issues behind them.

Famous Painters

Many famous painters used art to express their passions. Vincent van Gogh (1853–1890) was a Dutch, Post-Impressionist painter. He used vivid color combinations and broad energetic brushstrokes to convey intense emotion.

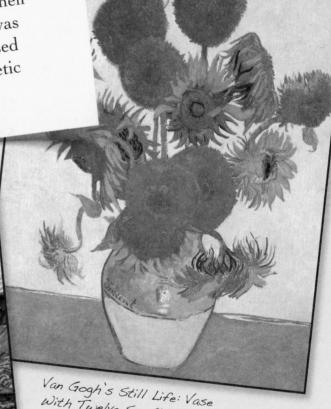

Van Gogh's Still Life: Vase With Twelve Sunflowers

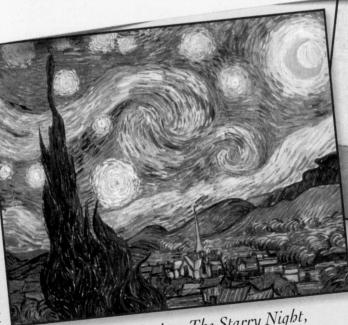

Vincent van Gogh's The Starry Night

In Van Gogh's painting *The Starry Night*, the swirling, tumultuous sky erupts with stars, clouds, and wind, reflecting his own tempestuous feelings.

During brief periods of happiness, Van Gogh painted many pictures of sunflowers. Vincent's golden yellow sunflowers shimmer with his excited optimism.

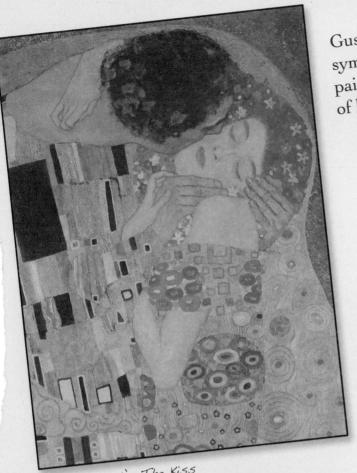

Gustave Klimt (1862–1918) was a symbolist painter from Austria. His painting *The Kiss* is a powerful depiction of love and passion.

Gustav Klimt's The Kiss

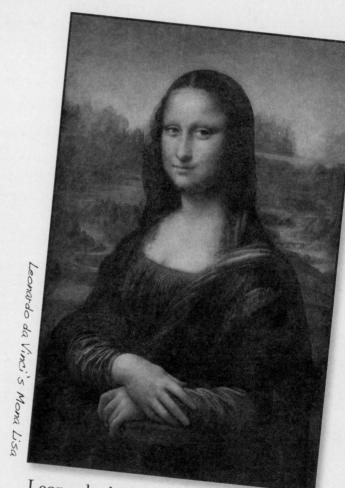

Leonardo da Vinci's Mona Lisa

Leonardo da Vinci (1452–1519), an artist of the High Renaissance, painted the *Mona Lisa*. His painting of this mysterious unknown woman creates an impression of peace and serenity.

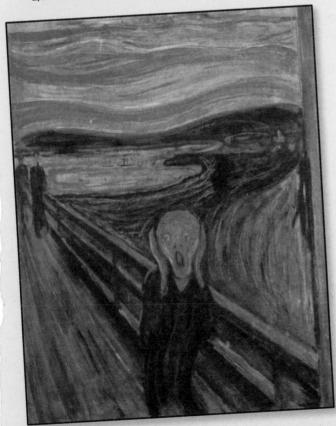

Edvard Munch (1863–1944) was an exponent of Symbolism and German Expressionism. His painting *The Scream* depicts a scream of nature. It expresses Munch's profound melancholy and anxiety.

Edvard Munch's The Scream

Tools and Materials

The most basic tools for Zen Doodling are scraps of paper and a pencil. Use whatever you have handy and get started! The important thing is to relax, enjoy the whole experience, and have fun.

Experiment

The tools and materials described here are the ones I used to produce the artwork in the following pages. Experiment with a wide range of readily available art materials. Find out what you enjoy using and what gives the best results. But...don't get stuck in a rut—experiment!

Pens

Black **fineliner pens** are waterproof and won't fade. They come in different sized nibs. Use a 0.1 mm nib for very fine, detailed doodles.

Marker pens are perfect for blocking in large areas of flat color.

Cartridge Paper

Cartridge paper comes in a range of weights (thicknesses) and textures. Smooth surfaces are best for detailed doodling. (Try out your materials first to ensure the paper doesn't cause the colors to bleed.)

Fineliner Pens

Fineliner pens come in a wide range of colors. They are ideal for coloring intricate shapes or creating detailed doodles. Use them to create subtle images and effects.

Bristol Board

Bristol board or paper also comes in a variety of thicknesses and textures. Both sides can be worked on, but smooth surfaces are best for detailed work.

Pencils

Graphite pencils come in different grades, varying from hard to soft. The softer the pencil, the darker the line it produces.

Pencil Crayons

Pencil crayons are ideal for blocking in areas of color. They produce subtle shades that can be layered to create depth and richness.

Small Sketchbook

Make Zen Doodling a habit! Keep a small pad or sketchbook with you at all times so you can doodle on the go!

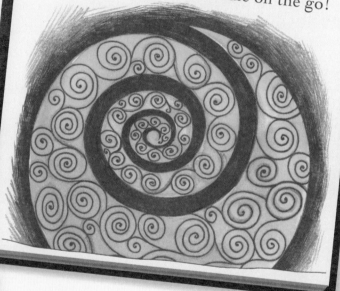

Metallic Gel Pens

Metallic gel pens are perfect for adding detail and richness to parts of the design. They come in a range of colors, including gold, silver, and bronze. **White gel pens** are most effective when used on black or dark colors.

Felt-tip Pens

Felt-tip pens come in a wide range of vivid colors and line widths. They are ideal for blocking in and adding bold details.

Watercolor Paints

Watercolor paints come in solid blocks, tubes, or liquid form. Dilute with water and use to paint patterns, block in color, or create washes.

Color Theory

The Color Wheel

The color wheel diagram, opposite, shows how colors are related. I find it very helpful when choosing color schemes for doodle designs and compositions.

Primary Colors

A primary color is one that cannot be made by mixing any other colors together. There are three primary colors: red, yellow, and blue.

Secondary Colors

A secondary color is one made by mixing together equal proportions of any two of the primary colors. There are three secondary colors: orange, green, and purple.

Tertiary Colors

A tertiary color is made by mixing equal proportions of a primary and an adjacent secondary color. There are six tertiary colors: red-orange, yellow-orange, yellow-green, blue-green, blue-purple, and red-purple.

The color wheel labels, arranged around the wheel:

RED

Red-purple

Red-orange

PURPLE

ORANGE

Blue-purple

Yellow-orange

BLUE

YELLOW

Blue-green

Yellow-green

GREEN

Complementary Colors

Complementary colors lie opposite each other on the color wheel. Used side-by-side they convey energy and surprise. Red and green, blue and orange, and yellow and purple are all sets of complementary colors.

Analogous Colors

Analogous colors lie next to one another on the color wheel. Analogous color schemes convey intense moods, emotions, and feelings. Green, yellow-green, and yellow are analogous colors.

Colorful Emotions

Color is an essential part of how we experience the world. Different colors can affect us psychologically by influencing our emotions or state of mind. Color can also have both positive and negative associations. For example, red reflects emotions of love and romance, yet it can also convey anger and aggression.

The color RED

Red is a powerful color that is stimulating and lively. The positive psychology of red includes: love, romance, warmth, energy, passion, excitement, lust, and joy of life. Its negative associations include anger, rage, defiance, strain, war, and danger.

The color ORANGE

Orange is the color of fire—it reflects strength and passion. The positive psychology of orange includes: stimulation, enthusiasm, change, sophistication, happiness, and edginess. Orange's negative associations include alarm, frustration, and heightened emotion.

HAPPINESS pleasure EMBARRASSMENT lust LOVE passion RAGE
relaxation TRANQUILITY calmness SERENITY loyalty COLDNESS

EXCITEMENT warmth STIMULATION edginess HOPE cheerfulness PUZZLEMENT curiosity SURPRISE mischievousness ENERGY

The color YELLOW

Yellow, the color of sunshine, is stimulating and uplifting. The positive psychology of yellow includes hope, cheer, optimism, intensity, warmth, curiosity, and happiness. Its negative associations include frustration, anger, forcefulness, and depression.

The color GREEN

Green is a color that implies restfulness and balance. The positive psychology of green includes energy, mischief, harmony, calmness, naturalness, health, and tranquility. Green's negative associations include envy, stagnation, and blandness.

The color BLUE

Blue is an intellectual color that soothes and calms us. The positive psychology of blue includes serenity, wisdom, loyalty, calmness, and truth. Its negative associations include coldness, lack of feelings, and unfriendliness.

The color PURPLE

Purple is a color that reflects creativity, richness, and luxury. The positive psychology of purple includes sophistication, spirituality, pleasure, happiness, wisdom, the exotic, and royalty. Its negative associations include arrogance, inferiority, and profanity.

Shading

Different Techniques

Shading specific areas of a doodle adds depth and can make the design look solid and three-dimensional. Specific sections can be "knocked back" with shading to make other areas "stand out."

Hatching and Cross-hatching...

Hatching is when parallel lines are drawn closely together. This creates the illusion of tone, shade, or texture in a drawing.

Cross-hatching is the layering of two or more sets of hatching that change direction to criss-cross.

To create darker tones, draw lines closer together and add more layers of hatching.

Scribbling and Smudging...

Scribbling makes an ideal shading texture. Increase the tone by making the scribbling more dense.

Add shade and create exciting textures by varying the shapes of the scribbles.

Blend and soften graphite pencil shading by using the tip of your finger to smudge it.

Before and After...

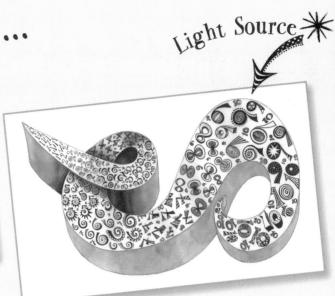

1 This black and white line artwork (above) looks flat and dull.

2 Choose a light source, then use watercolors to paint the curved sides. Paint areas that catch less light with dark orange and those that catch the light with pale yellow.

3 Add shading by using hatching and cross-hatching. In this example, I used a combination of pencil, pencil crayon, and colored ballpoint; however, you can use whichever medium you prefer.

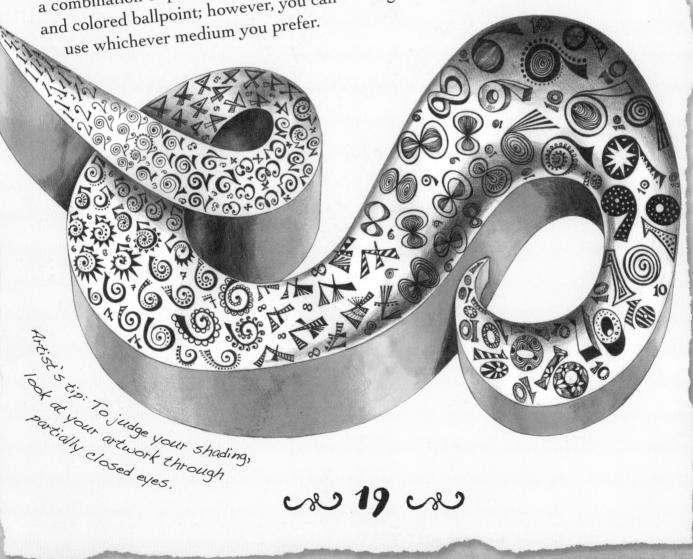

Artist's tip: To judge your shading, look at your artwork through partially closed eyes.

Getting Started

If you can write the numbers 1 to 10, then you can Zen Doodle! Start by drawing a selection of 1's, then some 2's, add swirls and dots…

…then add scallop shapes around the edges. Now add tiny swirls, or lines that fan outward.

Exaggerate and alter the shapes of the numbers. Embellish them with lines and triangles.

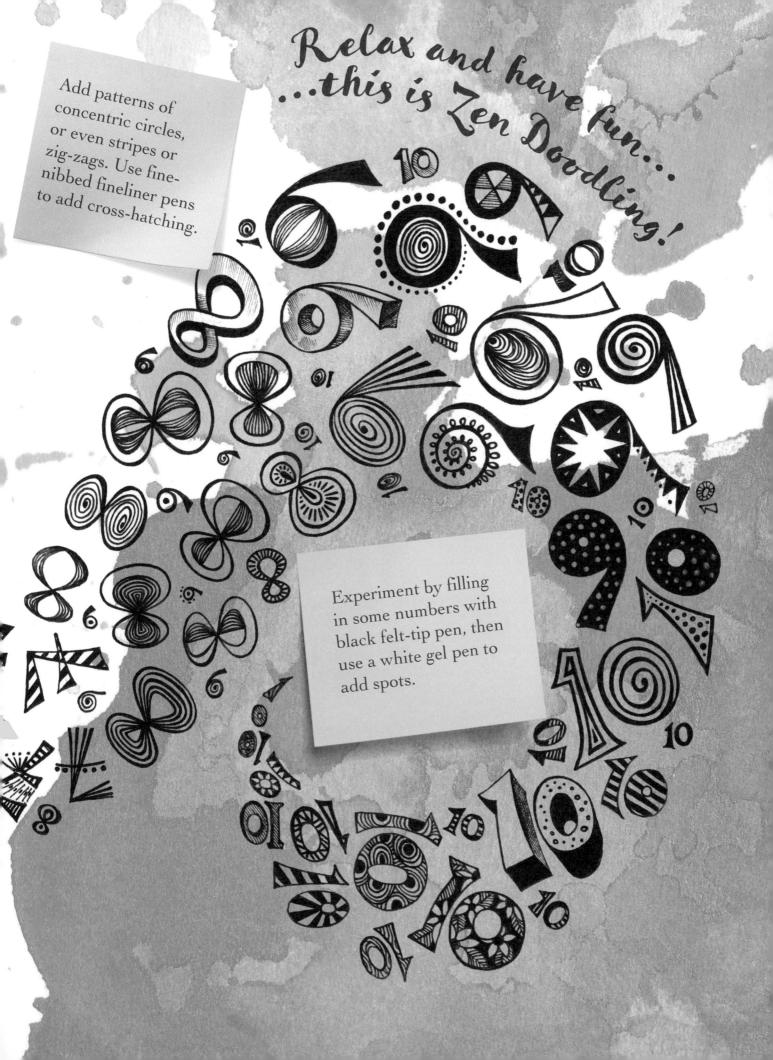

Relax and have fun...
...this is Zen Doodling!

Add patterns of concentric circles, or even stripes or zig-zags. Use fine-nibbed fineliner pens to add cross-hatching.

Experiment by filling in some numbers with black felt-tip pen, then use a white gel pen to add spots.

Art Journal

Keep an art journal of your ongoing experimental doodles. It's a great way to explore and reflect on your emotions as your journey continues. Try not to put pressure on yourself to create special Zen Doodles. Instead, focus purely on the doodling itself in order to lose yourself in the act of creating. For me, this is the best part of all, as it's not only relaxing but meaningful.

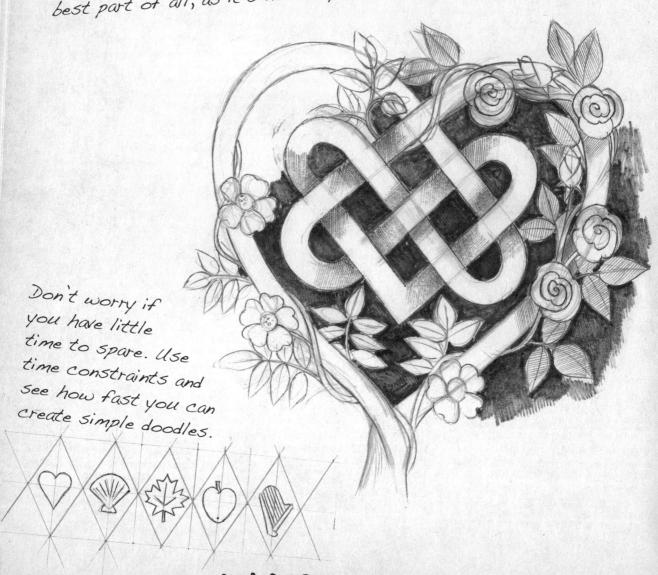

Don't worry if you have little time to spare. Use time constraints and see how fast you can create simple doodles.

"*A drawing is simply a line going for a walk.*"

Paul Klee

This is also true for Zen Doodling!

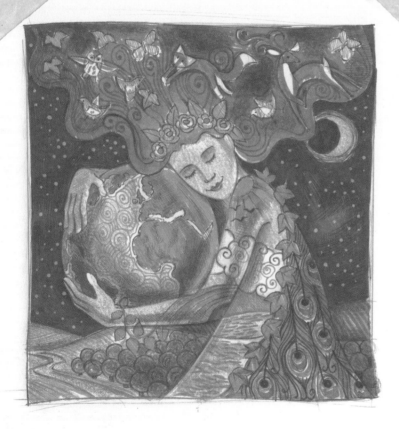

Love

24

Chapter Two

"Life is the flower for which love is the honey."

Victor Hugo

Mood of Love

Love is an essential force that drives humankind. It determines who we are and how we live our lives. The word "love" is versatile and hard to define. We think of love as a powerful emotion, imbued with feelings of deep affection. As well as romantic love, there is the love of a child for their parent, a parent's love for their child, or love for family and country.

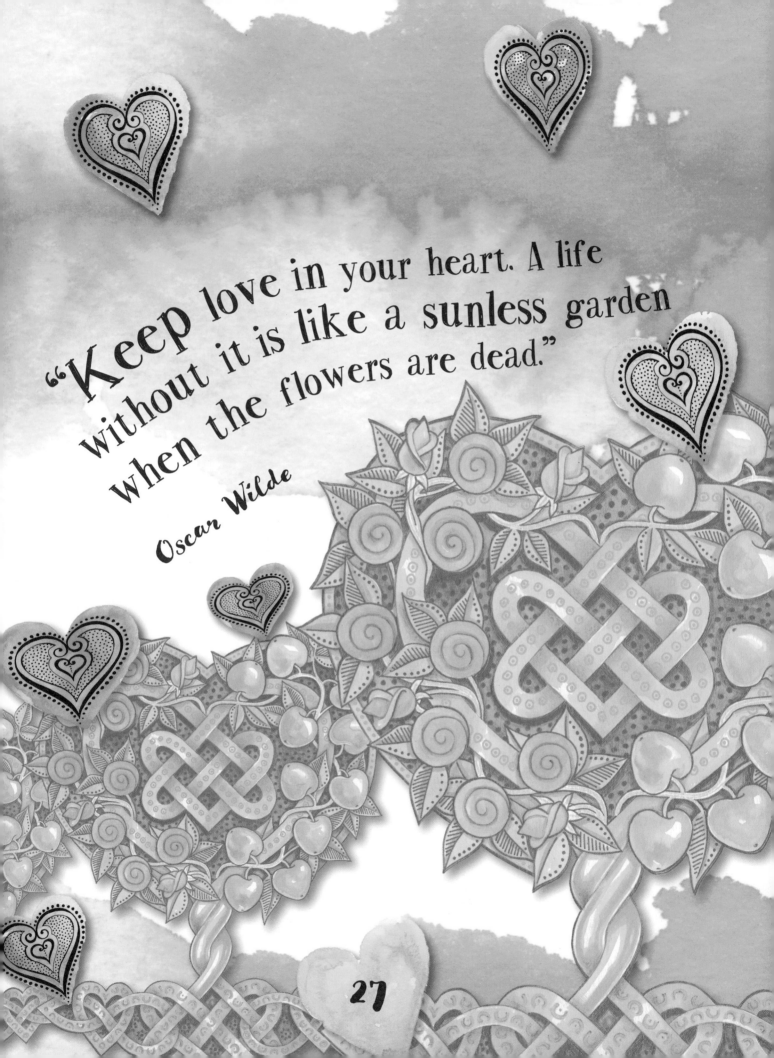

"Keep love in your heart. A life without it is like a sunless garden when the flowers are dead."

Oscar Wilde

27

Collage of Love

29

Celtic Love Knot

In ages past, Celtic sailors in far-off lands remembered their sweethearts at home by weaving rope mementos for them. My design is inspired by this idea and by Celtic love knots. It is constructed from two entwined heart shapes that form another pair of smaller heart shapes where they cross. The intertwined "knots" symbolize harmony, deep love, and affection.

Deconstruct the Design

1 Draw a square at an angle so that the corners lie at the top, bottom, and on both sides.

2 Using a ruler, measure four parallel, equidistant lines. Lightly pencil in the four lines.

3 Repeat on the adjacent side. Pencil in four more lines to create a grid.

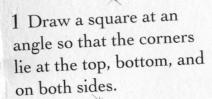

4 Pencil in a vertical line from top to bottom. Then draw in a horizontal line.

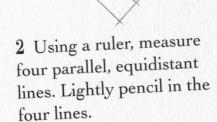

5 Draw an arc from the left corner to meet the third gridline (as shown). Add a smaller arc inside.

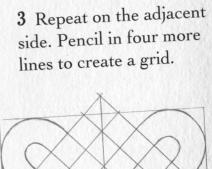

6 Repeat by drawing two more arcs on the right side of the design.

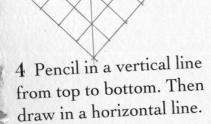

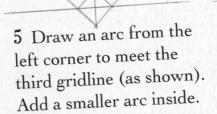

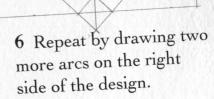

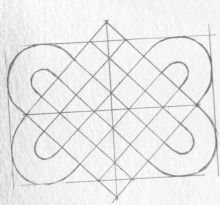
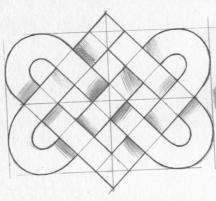

7 Pencil in two more arcs on the bottom half of the design, right and left.

8 Use pencil shading to indicate "ropes." Outline with black fineliner pen.

9 Erase the pencil guidelines. Color in your design. Add pencil crayon and pencil shading.

Design Concept

The design concept I chose was a combination of the Celtic love knot shapes and a rose bush. I wasn't sure how this would work, so I began by sketching the Celtic knot. Then I drew two curving branches from the top downward to form an enclosing heart shape. I completed the rose bush by turning the base of the heart shape into a tree trunk.

Immortal Love

Throughout history, the rose has carried with it significant symbolic meanings. In addition to immortal love it also stands for balance, hope, new beginnings, and secrecy.

Intertwined

Design Roughs

It's really worthwhile to work out the composition and design elements that you want to include before you draw out a piece of artwork for doodling. I like to make thumbnail sketches, or pencil roughs, first. These can be really simple or quite detailed, depending on what suits your needs.

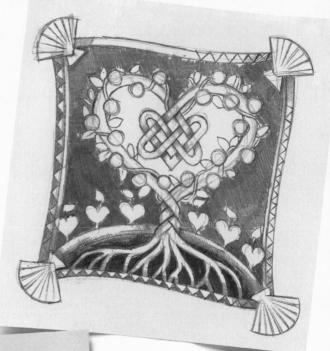

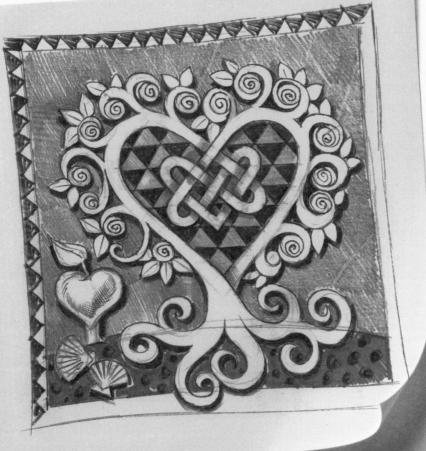

Detailed Roughs

These pencil roughs are fairly detailed. I wanted to incorporate several elements in the same design and felt it was important to check if this made the image look too "busy" or not. I tried changing the style of the tree and used a triangular pattern in different ways. Small changes can alter a design enormously.

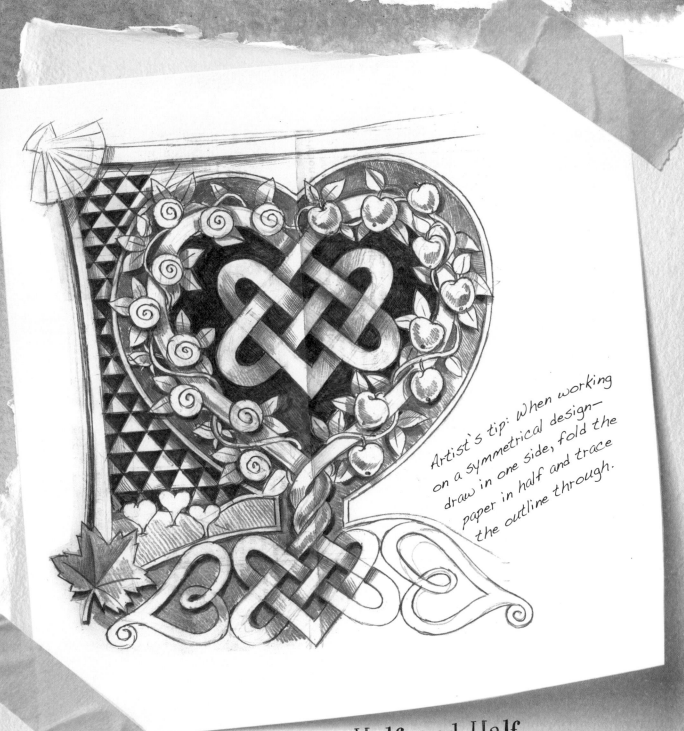

Artist's tip: When working on a symmetrical design— draw in one side, fold the paper in half and trace the outline through.

Half and Half

As an experiment, I decorated half the tree with rambling roses, and the other with heart-shaped apples. The frame makes a useful device for adding other elements, such as the maple leaf and scallop shell. Maybe a harp and cupid could be drawn in the other two corners. The triangular pattern in the background adds a vibrant contrast to the overall design.

Metaphorical

The above rough uses the image of the tree spreading its intertwined roots deep into the ground as a metaphor for love in all its various guises.

Color Rough

To capture the passionate emotion of love, the composition needs the addition of color. Keep experimenting with the design as you work out your color roughs.

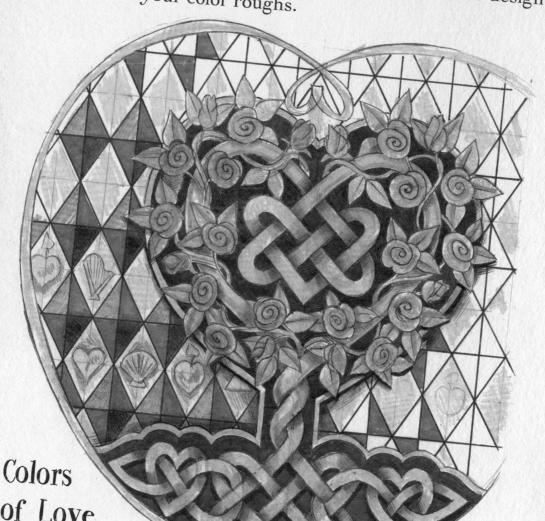

Colors of Love

Refer to the color wheel (pages 14–15) and select colors that reflect love: shades of red, pink, orange, and green. Gold adds richness and warmth to the design.

Gold symbolizes optimism, compassion, and love. In this version of the design, a 3D pattern is used for the background and the picture frame is heart-shaped.

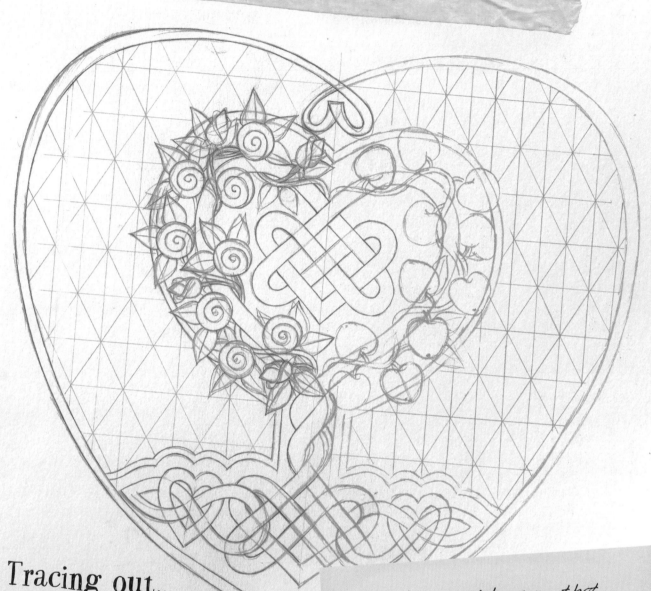

Tracing out...

Start by penciling in a vertical line through the center of your paper. Draw out the main elements of one half of the design only. Trace the drawing. Use a soft pencil to shade the back of the tracing paper. Turn the tracing over, using the vertical line to position it, and transfer the design to the other side.

Artist's tip: Make sure that your pens and colors don't bleed on the paper or board you intend to use. I chose to work on smooth watercolor paper, as I wanted to block in the background colors with watercolor paints.

Depth of Color

Watercolor

Watercolor paints can produce delicate layers of transparent color. To create richer tones, add less water to the paints. For a more subtle blend, use more water and let the colors bleed into one another. Let the paint dry completely before applying any doodling.

Watercolor background

Layering

Start adding layers of color using whatever mediums you prefer. I used a combination of felt-tip and fineliner pens, with colored ballpoint pen and pencil crayons.

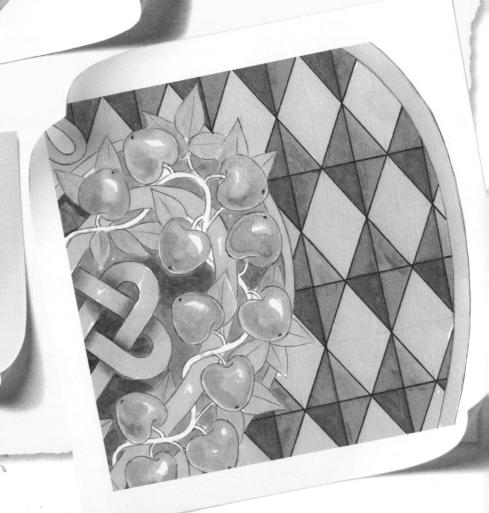

Light Source

First choose the direction of your light source. Use black fineliner pen to block in areas of dark shadow. Add shading to the Celtic knot. Use pencil crayons and colored ballpoint pens to produce soft hatching.

3D Effect

To enhance the 3D effect of the background, add dark purple fineliner stripes to the triangle furthest from the light source. Add pale pink dots to the triangles nearest the light source. Doodle patterns on the remaining two triangles using red and light purple fineliner pens.

≈ 37 ≈

Power of Love

Love is the most powerful and magical force in the universe. As you doodle your artwork, fill your mind with thoughts of people you love and the pleasure you get from giving to others. Think of all the things that you love to share. Try to capture the sense of balance and stability needed for love to thrive by the use of soft shadows and subtle blends of color.

Background pattern

Start by penciling in a diamond grid...

Draw out these shapes on some scrap paper: heart, shell, maple leaf, apple, and harp. Trace the designs onto the artwork. Use pencil crayons and a pencil to draw the designs. Finish off with a gold gel pen.

Finishing off

Complete the design by adding simple patterns of dots, circles, and lines. Use a fine-tipped black felt-tip pen and gold gel pens. Finish shading in any areas that need it.

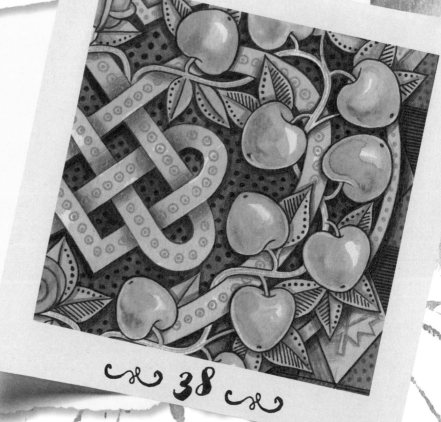

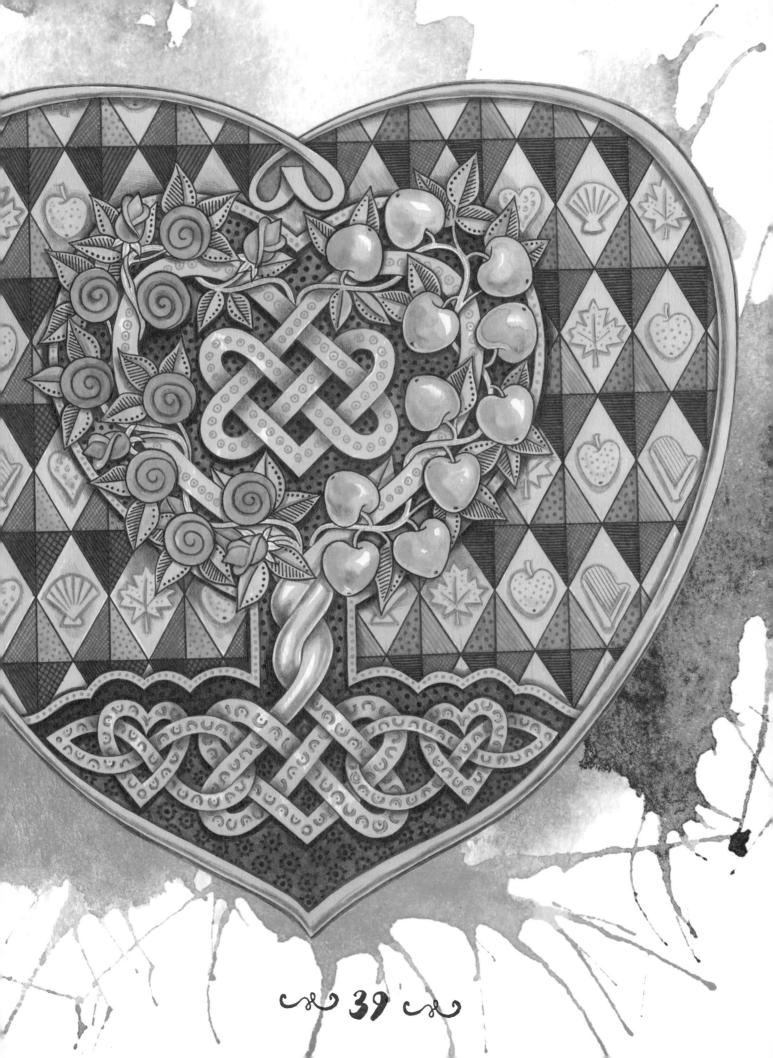

Sadness and Loss

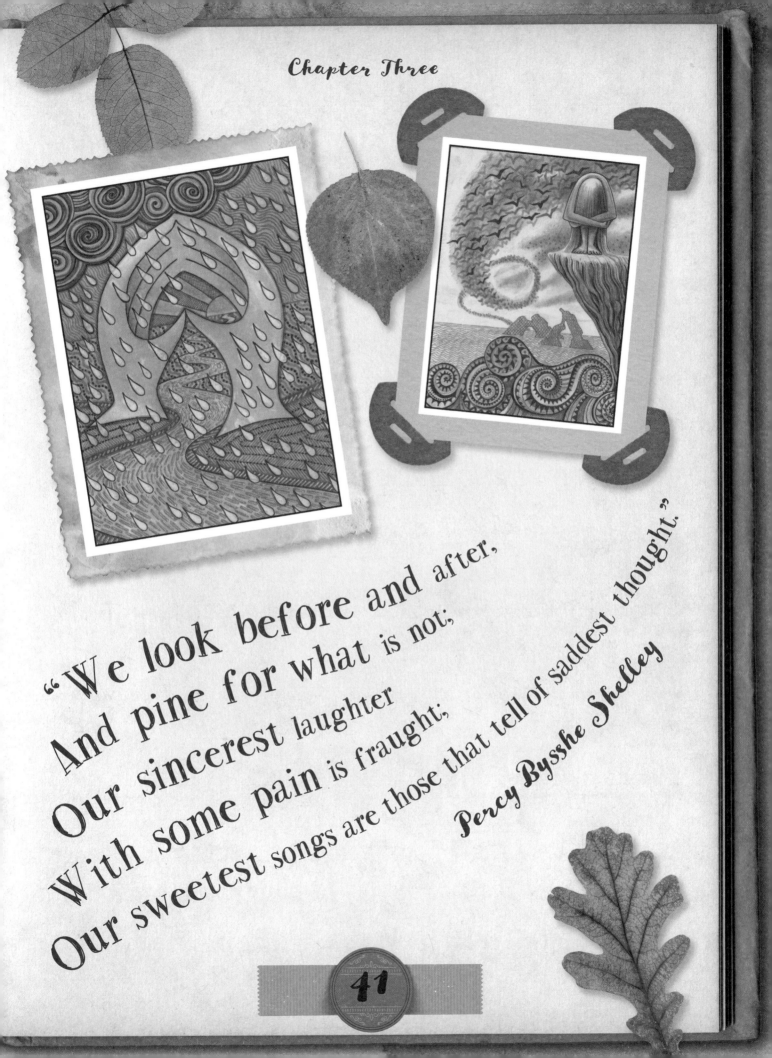

"We look before and after,
And pine for what is not;
Our sincerest laughter
With some pain is fraught;
Our sweetest songs are those that tell of saddest thought."

Percy Bysshe Shelley

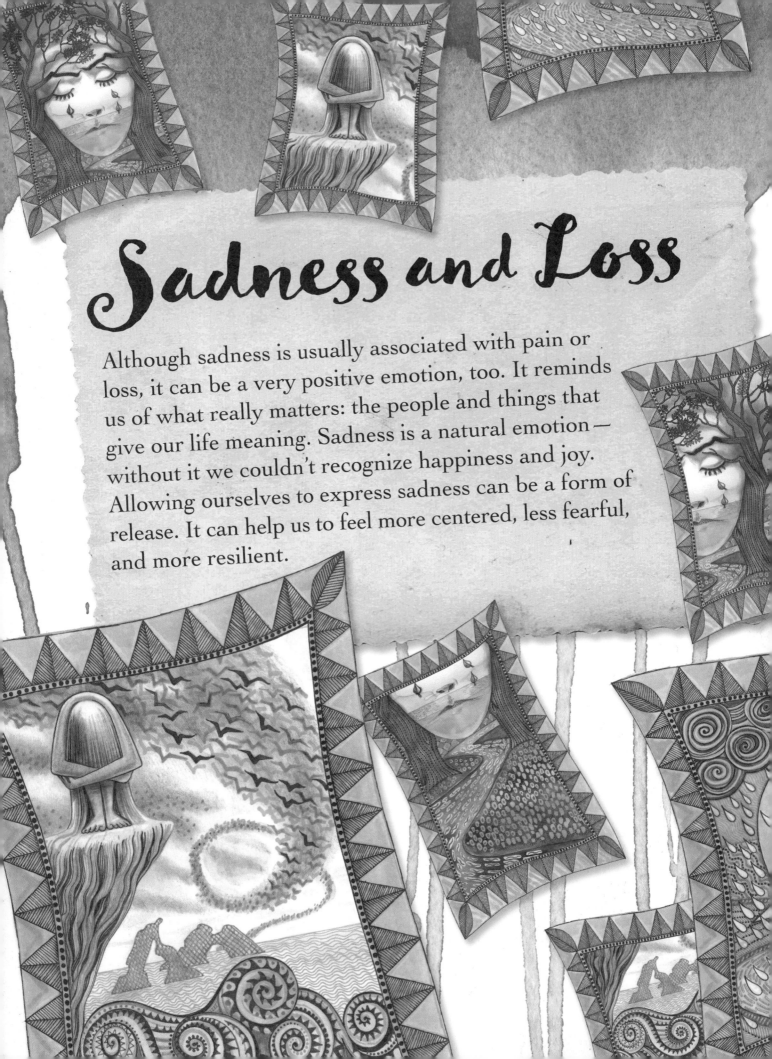

Sadness and Loss

Although sadness is usually associated with pain or loss, it can be a very positive emotion, too. It reminds us of what really matters: the people and things that give our life meaning. Sadness is a natural emotion—without it we couldn't recognize happiness and joy. Allowing ourselves to express sadness can be a form of release. It can help us to feel more centered, less fearful, and more resilient.

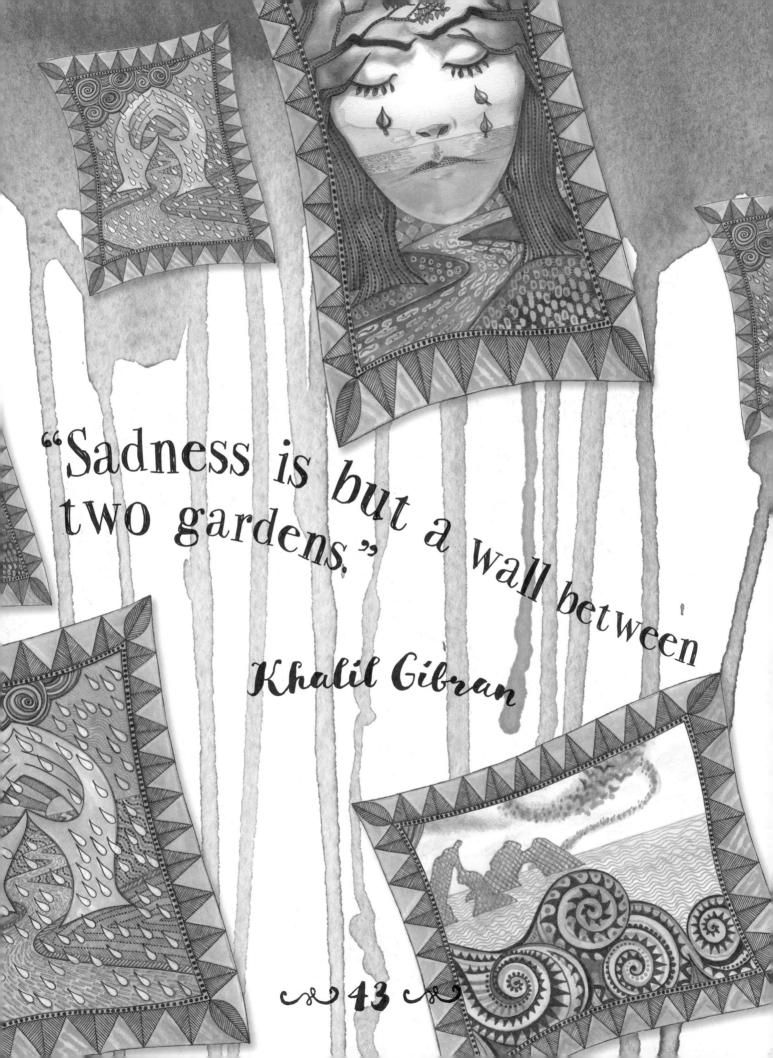

"Sadness is but a wall between two gardens."

Khalil Gibran

Collage of Sadness

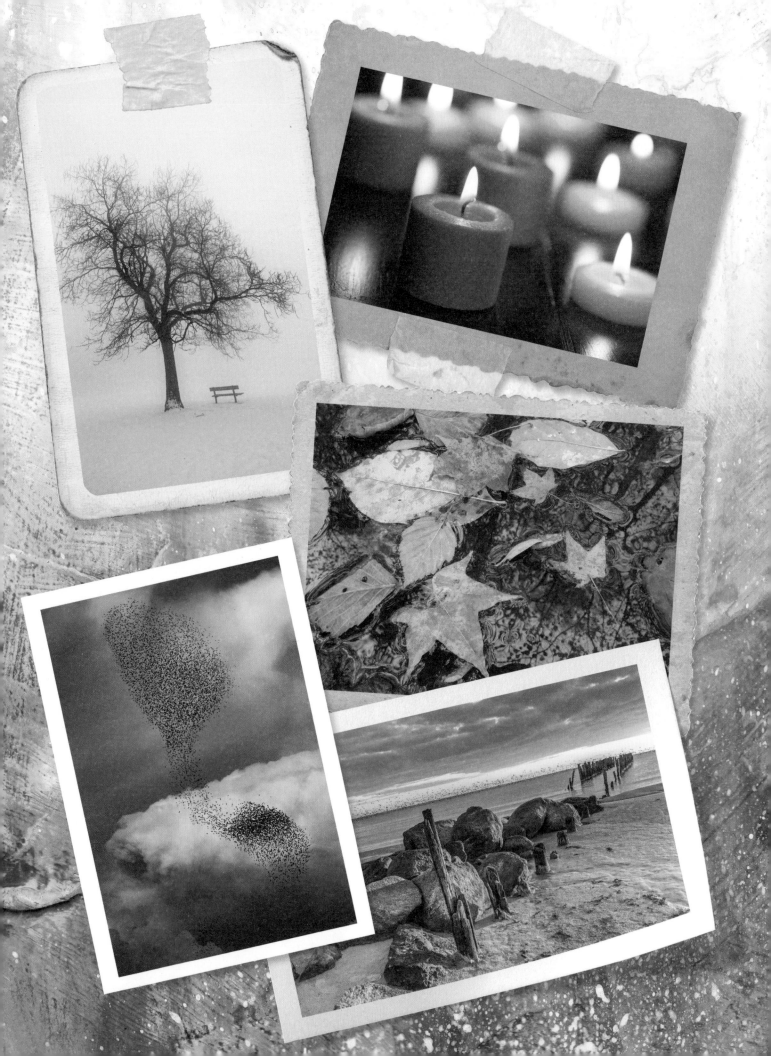

Different Ideas

Thumbnail Sketches

Thumbnail sketches are small, initial drawings on paper. They are usually executed quickly and are ideal for exploring different design ideas and compositions. Use any medium you have on hand and work in color or black and white.

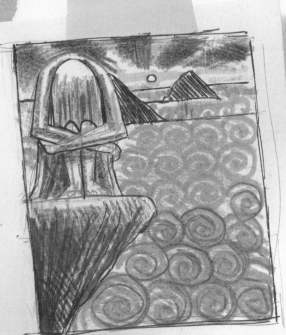

Isolation

In this thumbnail (above) and design rough (right), I have tried to capture the feeling of isolation caused by sadness and loss. The solitary, huddled figure is perched on the edge of a precipitous clifftop. The sea below is turbulent, and threatening storm clouds and migrating birds fill the sky above. These ideas symbolize emotional turmoil.

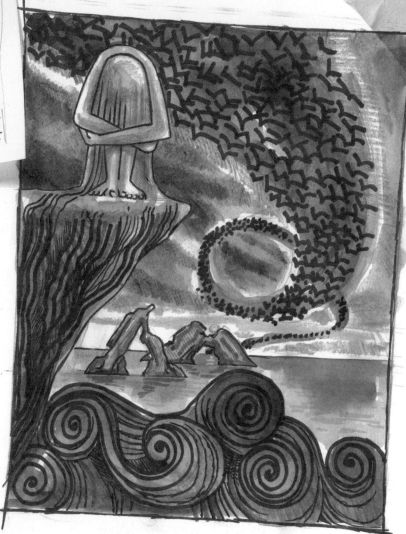

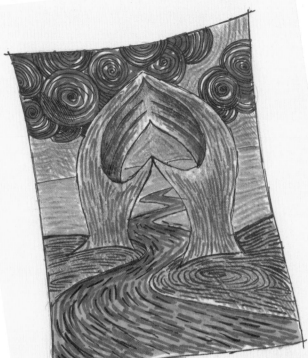

Hands Reaching Out

Both these roughs feature hands reaching out in comfort as the central motif. The winding river that snakes into the distance echoes the sense of loss. In the top sketch, swirling lines follow and emphasize the main shapes of the design. This adds emotional intensity to the image.

Wax Resist

For this version (right), I used a wax resist technique to replicate falling rain. Start by drawing out the design in pencil. Then use a white wax crayon (or white candle) to draw in slanting rain drops. Paint over the design with watercolor washes. The wax marks will remain white and produce an effective raindrop pattern.

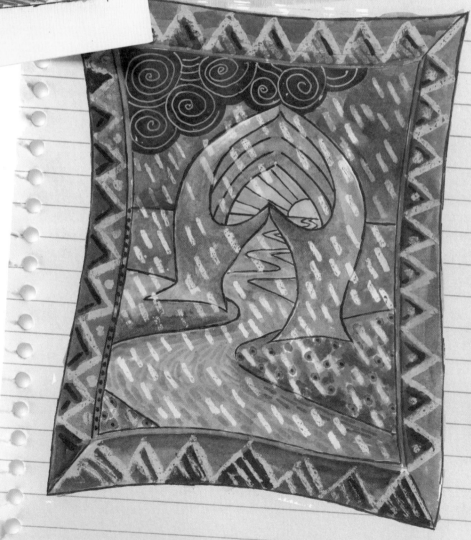

Optical Illusion

Face in the Tree

An optical illusion is an image that deceives the eye by appearing to be something else. Depending on how your brain analyzes the rough sketch below, you may see a bleak landscape with a river and trees or a sad, weeping face clasped between two hands.

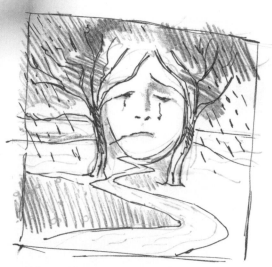

Thumbnail Sketch

Forming Shapes

To create the optical illusion of a weeping face, I used branches to suggest the eyes, and falling leaves for the teardrops and nose. The trees curve in to form the shape of a face, and are drawn to look like two hands. The lips are formed from small hills in the distance, and the shoulders from the curved lines of the landscape.

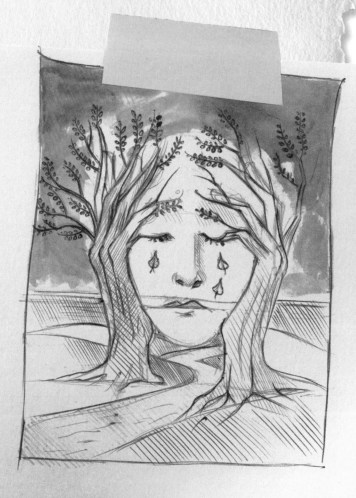

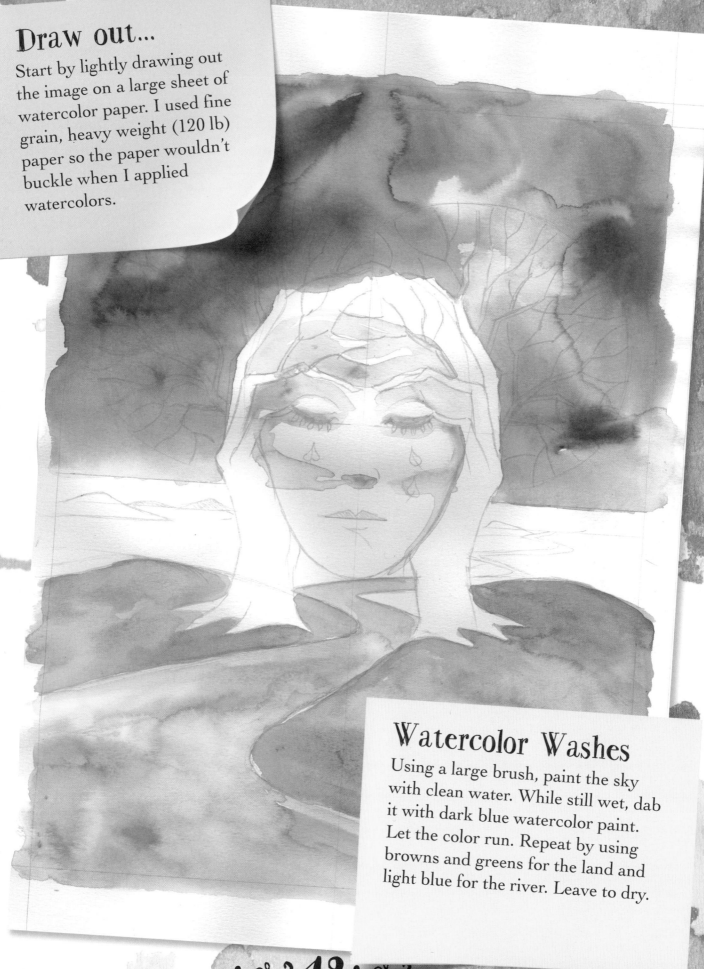

Draw out...
Start by lightly drawing out the image on a large sheet of watercolor paper. I used fine grain, heavy weight (120 lb) paper so the paper wouldn't buckle when I applied watercolors.

Watercolor Washes
Using a large brush, paint the sky with clean water. While still wet, dab it with dark blue watercolor paint. Let the color run. Repeat by using browns and greens for the land and light blue for the river. Leave to dry.

Exciting Effects

Drawing Out

Draw out both trees using a 0.1 mm black fineliner pen. Begin by drawing in the tree trunks, then add branches and finally leaves. Paint the tree and branches with light brown watercolor. Once dry, use a brown felt-tip pen to doodle curving lines to create the texture of the tree bark.

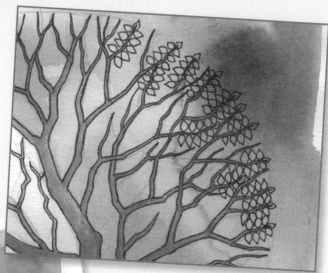

Subtle Shading

Color in the leaves with fineliner pens in shades of green. Now use pale blue pencil crayons or a ballpoint pen to lightly shade in the contours of the "face."

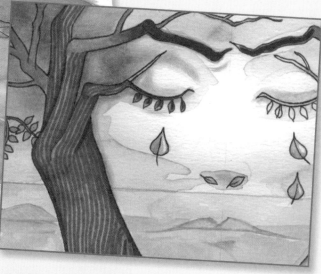

Resist Technique

This technique uses masking fluid (latex solution) to mask out parts of the image before the watercolor paint is applied. I painted on the masking fluid with a series of short, parallel brush strokes, to capture the movement of the flowing stream.

1 Stir the masking fluid. Use an old paintbrush to paint on masking fluid "dashes." Leave to dry.

2 Apply a watercolor wash over the masked area. Leave to dry.

3 Gently rub off the masking fluid with your fingertip.

Artist's tip: Before you start, rub the wet paint brush on a bar of soap. This will make it easier to wash out the masking fluid. Clean your brush as soon as you have finished painting it on.

Movement and Texture

It's always exciting to rub off dried masking fluid to reveal the underlying results. I also used the resist technique (above) to create movement and texture on the riverbanks.

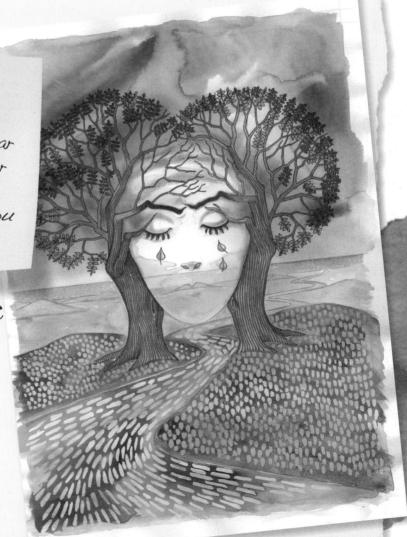

Letting Go

Before adding patterns to the artwork, close your eyes and try to visualize your feelings of sadness. This could be some past loss that you've never accepted, or perhaps a more recent grief. Open your eyes and as you start to Zen Doodle, try to let go of your feelings...

Simple and Subtle

Use simple, subtle Zen Doodles so as not to detract from the dramatic background washes and patterns created by the resist technique.

Brown fineliner pen dots on the tree trunks.

Dots and swirls in pale blue fineliner pens for the sky.

Swirls and dots in light and dark brown fineliner pens for the right-hand river bank.

Brown fineliner pen dots on the tree branches.

Wavy patterns in blue fineliner pen for the stream.

Light brown dots in felt-tip pen with dark green fineliner fringes on the left-hand river bank.

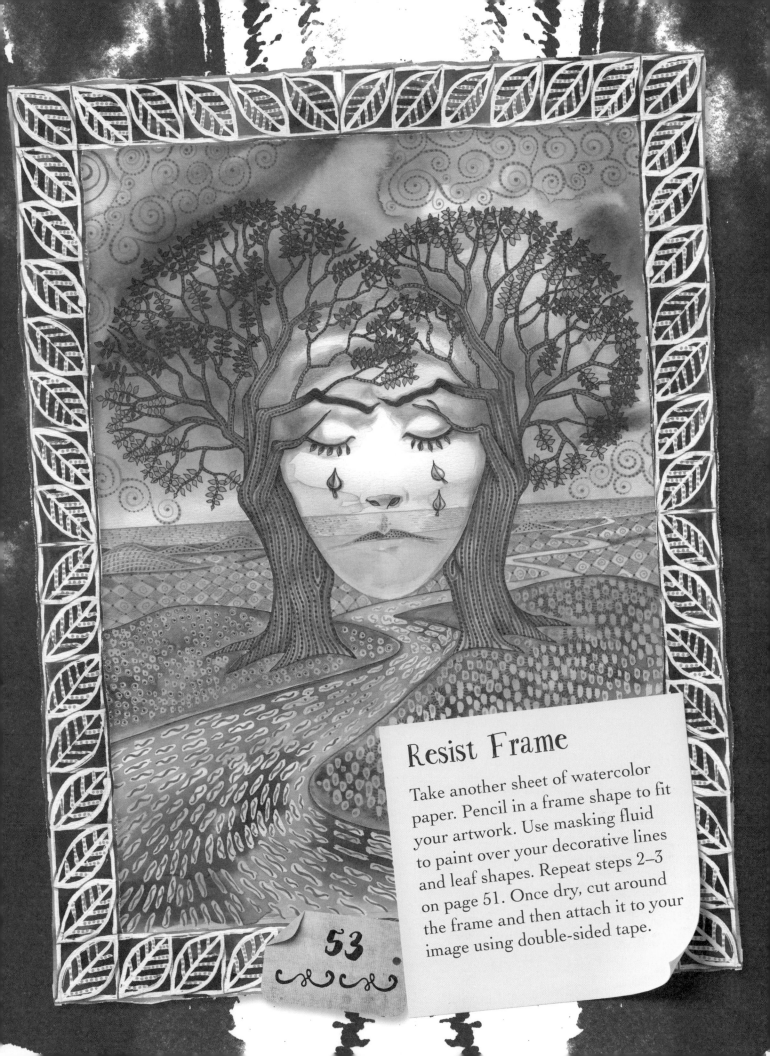

Resist Frame

Take another sheet of watercolor paper. Pencil in a frame shape to fit your artwork. Use masking fluid to paint over your decorative lines and leaf shapes. Repeat steps 2–3 on page 51. Once dry, cut around the frame and then attach it to your image using double-sided tape.

ANGER AND RAGE

"When anger rises, think of the consequences."

Confucius

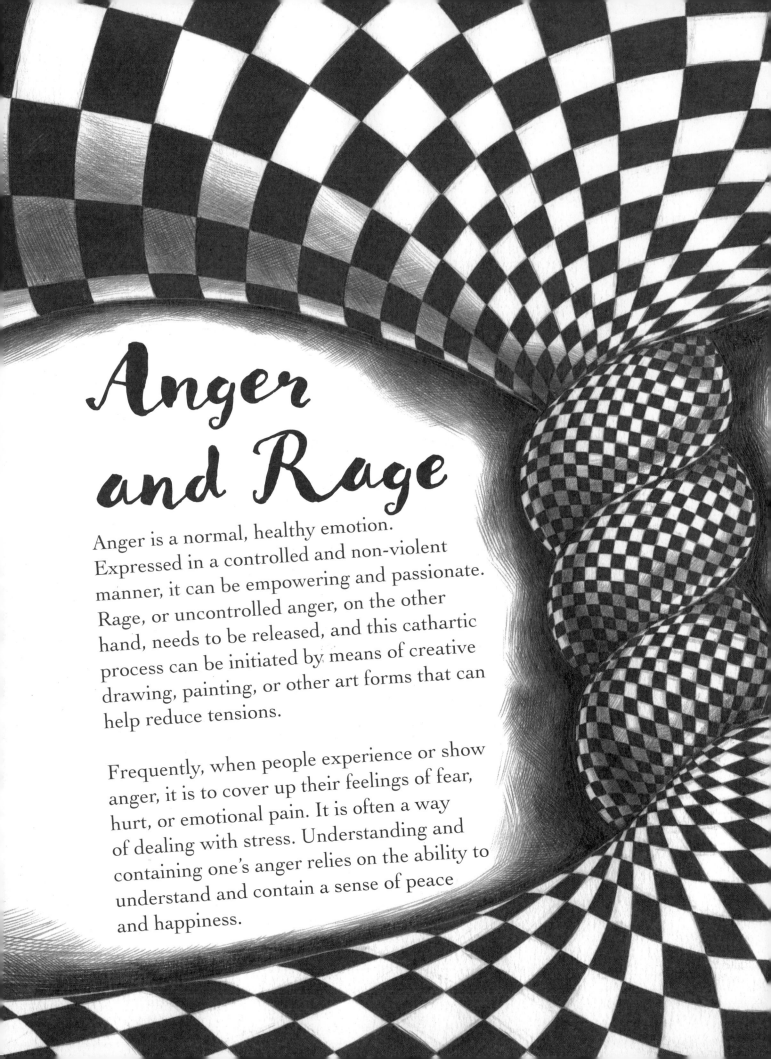

Anger and Rage

Anger is a normal, healthy emotion. Expressed in a controlled and non-violent manner, it can be empowering and passionate. Rage, or uncontrolled anger, on the other hand, needs to be released, and this cathartic process can be initiated by means of creative drawing, painting, or other art forms that can help reduce tensions.

Frequently, when people experience or show anger, it is to cover up their feelings of fear, hurt, or emotional pain. It is often a way of dealing with stress. Understanding and containing one's anger relies on the ability to understand and contain a sense of peace and happiness.

"Holding on to anger is like grasping a hot coal with the intent of throwing it at someone else; you are the one who gets burned."

Buddha

Anger Collage

Seeing Red

Spontaneous Painting

This painting on the right was created with complete spontaneity. Before you start, make sure you won't be interrupted. Choose a color scheme and then set out the materials and equipment you intend to use. Clear your mind of everyday problems and relax completely. Now begin applying color. Use brush strokes or splashes, and scribble or doodle on the paper. Allow your subconscious mind to express itself!

Red gel pen, felt-tip pen with red ballpoint pen shading

Red and white sketch

Inner Turmoil

In contrast, this red and white sketch (left), was an exercise in drawing what I felt, rather than what I thought. It was only after I had drawn the twisted knot with its intricate checkered pattern that I realized it reflected my mind spiraling out of control, filled with conflicting thoughts.

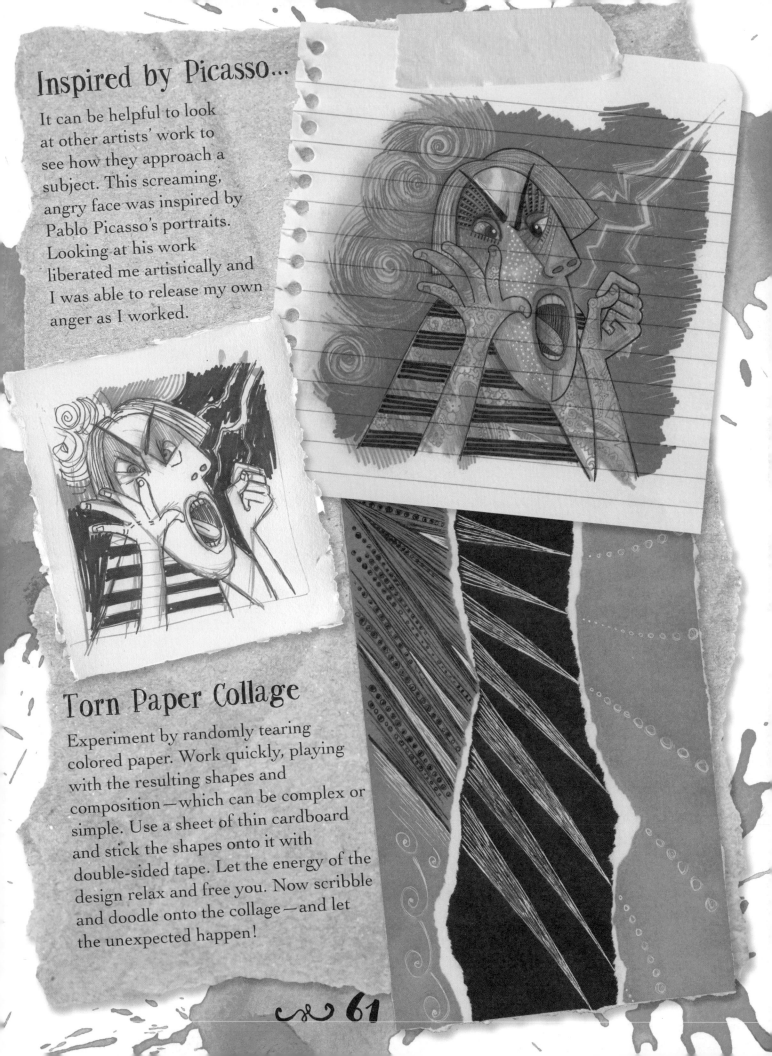

Inspired by Picasso...

It can be helpful to look at other artists' work to see how they approach a subject. This screaming, angry face was inspired by Pablo Picasso's portraits. Looking at his work liberated me artistically and I was able to release my own anger as I worked.

Torn Paper Collage

Experiment by randomly tearing colored paper. Work quickly, playing with the resulting shapes and composition—which can be complex or simple. Use a sheet of thin cardboard and stick the shapes onto it with double-sided tape. Let the energy of the design relax and free you. Now scribble and doodle onto the collage—and let the unexpected happen!

Roaring Tiger
Symmetrical Design

The fierce expression of a roaring tiger makes an exciting theme for a Zen Doodled print depicting anger. The tiger's black stripes and symmetrical design create a stunning graphic image.

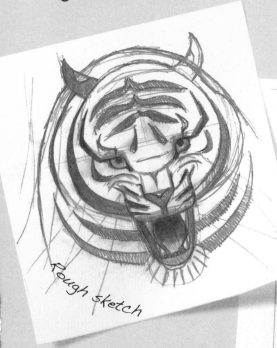

Rough sketch

Rough Sketch

Start by making a sketch of an angry tiger's face. Emphasize the big cat's fierce emotion by paying special attention to its eyes and the line of its jaw.

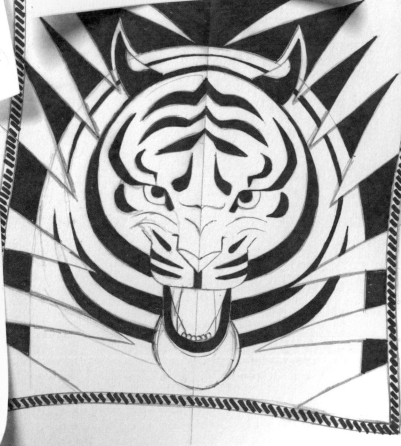

Print Design

Develop a print design based on your initial sketch. Simplify the outline of the tiger and the shape of its stripes. To replicate the finished print, color in the stripes with a black felt-tip pen.

Printing Plate

This simple printmaking technique uses indented styrofoam as a printing block. The styrofoam is inked with a brayer roller, then pressed onto paper, which is burnished with a spoon. The print is peeled off the block as a mirror image of the design.

You Will Need:

- Styrofoam sheet, from art or craft stores (or recycled styrofoam food trays)
- Dry ballpoint pen to use as a stylus
- Brayer roller
- Water-based block-printing color
- Smooth, flat surface for inking the roller (such as a baking tray)
- Large spoon for burnishing
- Old newspapers to protect work surfaces
- Black paper to print on

Method:

1 Pencil over the back of your drawing. Trace the lines of your design onto the styrofoam.

2 Indent the design onto the styrofoam using a dry ballpoint pen as a stylus.

3 Load the brayer by rolling ink onto a smooth surface. Roll ink onto the styrofoam block.

4 Lay a sheet of paper on top of the styrofoam block. Burnish it with a spoon.

5 Carefully peel the print off the plate and leave to dry.

To make more prints, repeat the process. If the ink gets too dry, wash and dry the block, brayer, and tray before re-using.

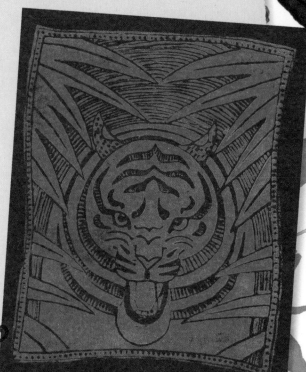

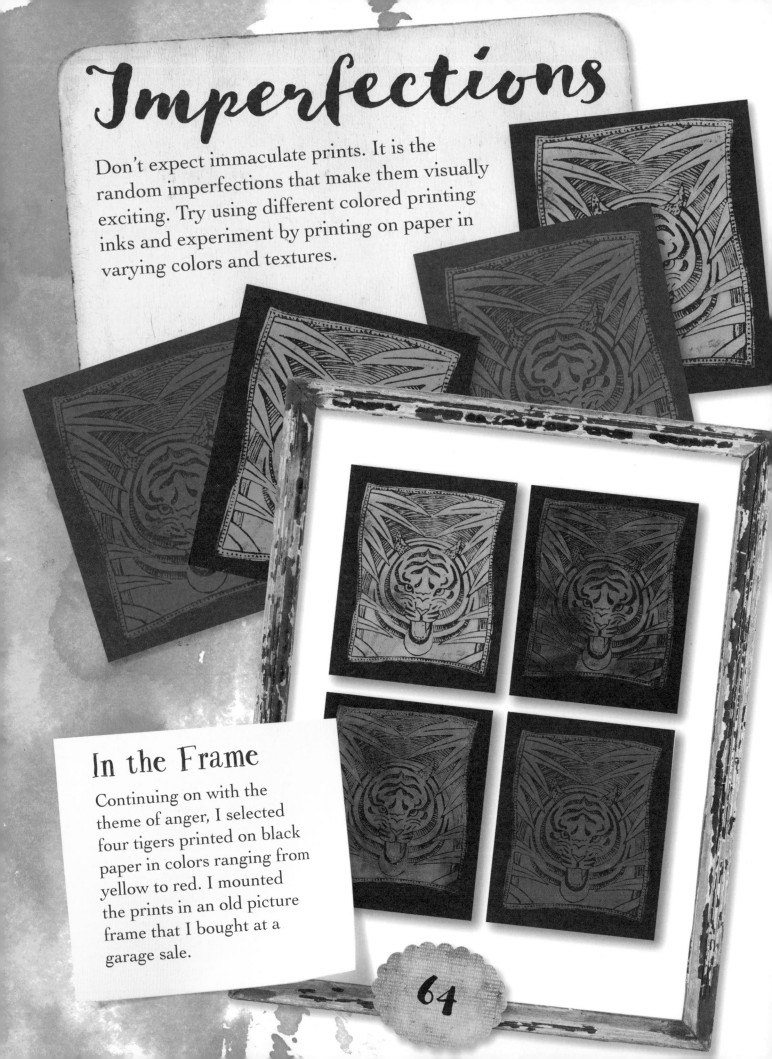

Imperfections

Don't expect immaculate prints. It is the random imperfections that make them visually exciting. Try using different colored printing inks and experiment by printing on paper in varying colors and textures.

In the Frame

Continuing on with the theme of anger, I selected four tigers printed on black paper in colors ranging from yellow to red. I mounted the prints in an old picture frame that I bought at a garage sale.

Zen Doodled Print

The ink must be completely dry (leave overnight or longer). Select a range of fineliner and gel pens in your chosen color scheme. Relax, breathe deeply, clear your thoughts and start doodling. As you doodle, try to open your mind, get in touch with some of your anger—confront it, and then gradually...let it go...

Doodling...

Highlight the tiger's eye and doodle its teeth and whiskers with white gel pen. Add black ballpoint pen shading around its muzzle to make it stand out.

Use a deep red fineliner pen to doodle onto the orange printing ink. Outline the red patterns with a gold gel pen.

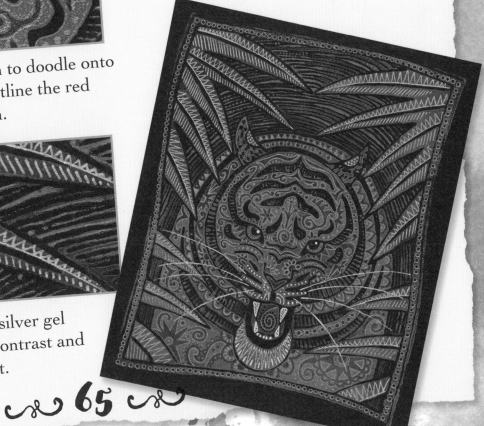

Doodle the leaves with a silver gel pen. This will add tonal contrast and make the leaves stand out.

Creative Border

Pattern Deconstruction

Barbed wire was the inspiration for my border to frame the tiger. The design looks deceptively simple, so I have deconstructed it into eight easy-to-follow steps:

1 Pencil in a simple grid. Using the grid as a guide, draw a long, regular wavy line that touches the top of the grid but not the base line.

2 Pencil in a second parallel wavy line underneath that touches the base of the grid (as shown).

3 Draw in a third wavy line as shown above. Use the grid as a guide.

4 Pencil in the last wavy line, parallel to the one in step 3 (as shown).

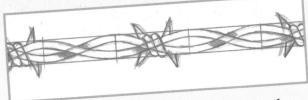

5 Mark each alternate point where the wavy lines cross. Then draw two pairs of angled lines to replicate the twisted wire "barbs."

6 Sketch in pointed ends to the barbs. Add pencil shading to indicate how the long wires weave in and out.

7 Outline the design using black fineliner pen. Erase the pencil lines.

8 Using black fineliner pen, fill in the background. Add shading using a black ballpoint pen.

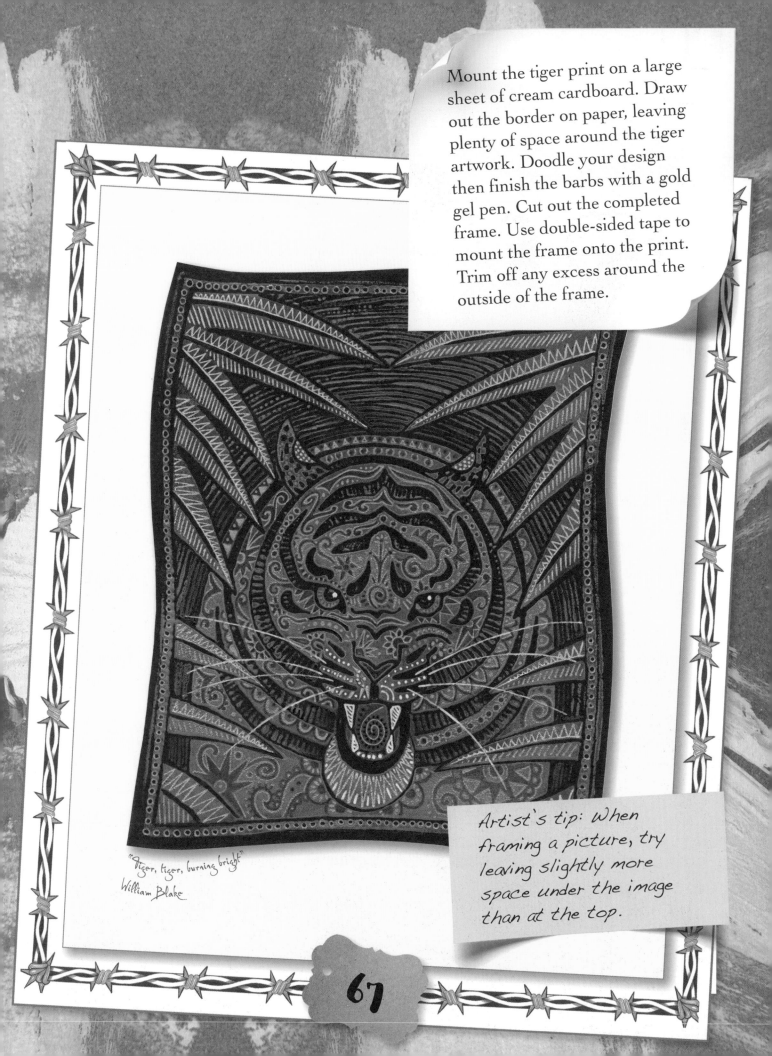

Mount the tiger print on a large sheet of cream cardboard. Draw out the border on paper, leaving plenty of space around the tiger artwork. Doodle your design then finish the barbs with a gold gel pen. Cut out the completed frame. Use double-sided tape to mount the frame onto the print. Trim off any excess around the outside of the frame.

"Tiger, tiger, burning bright"
William Blake

Artist's tip: When framing a picture, try leaving slightly more space under the image than at the top.

Peace and Tranquility

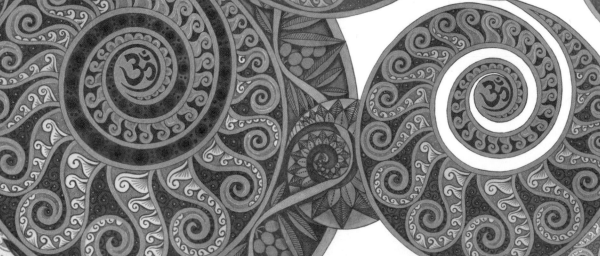

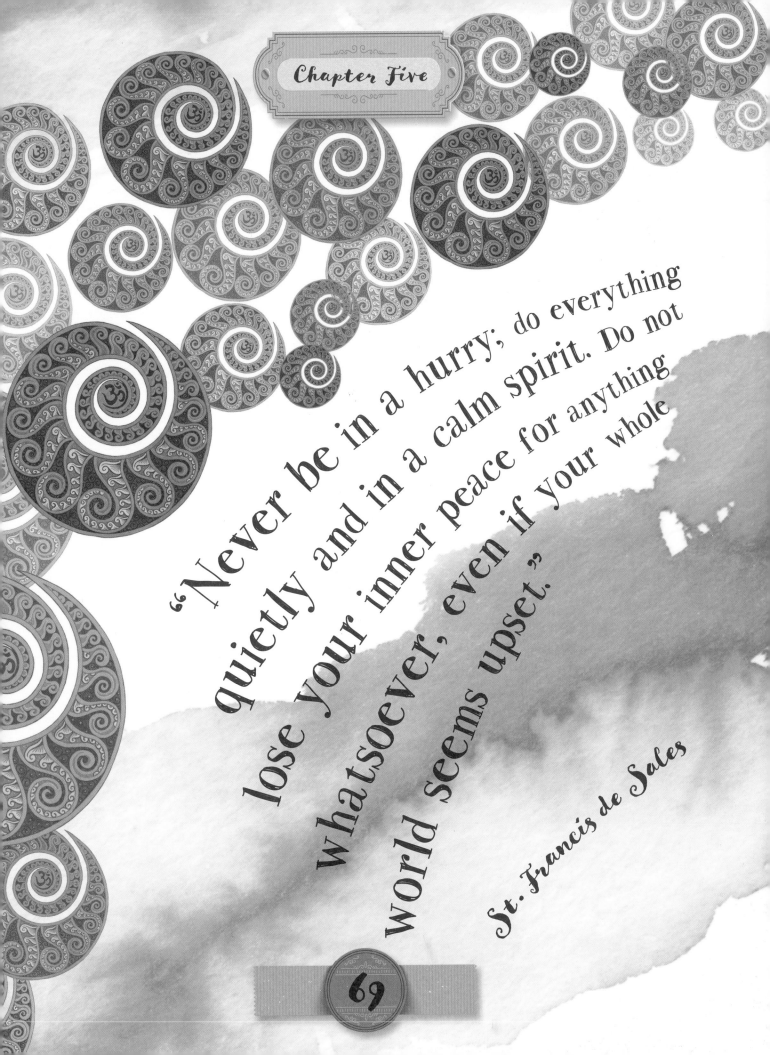

"Never be in a hurry; do everything quietly and in a calm spirit. Do not lose your inner peace for anything whatsoever, even if your whole world seems upset."

St. Francis de Sales

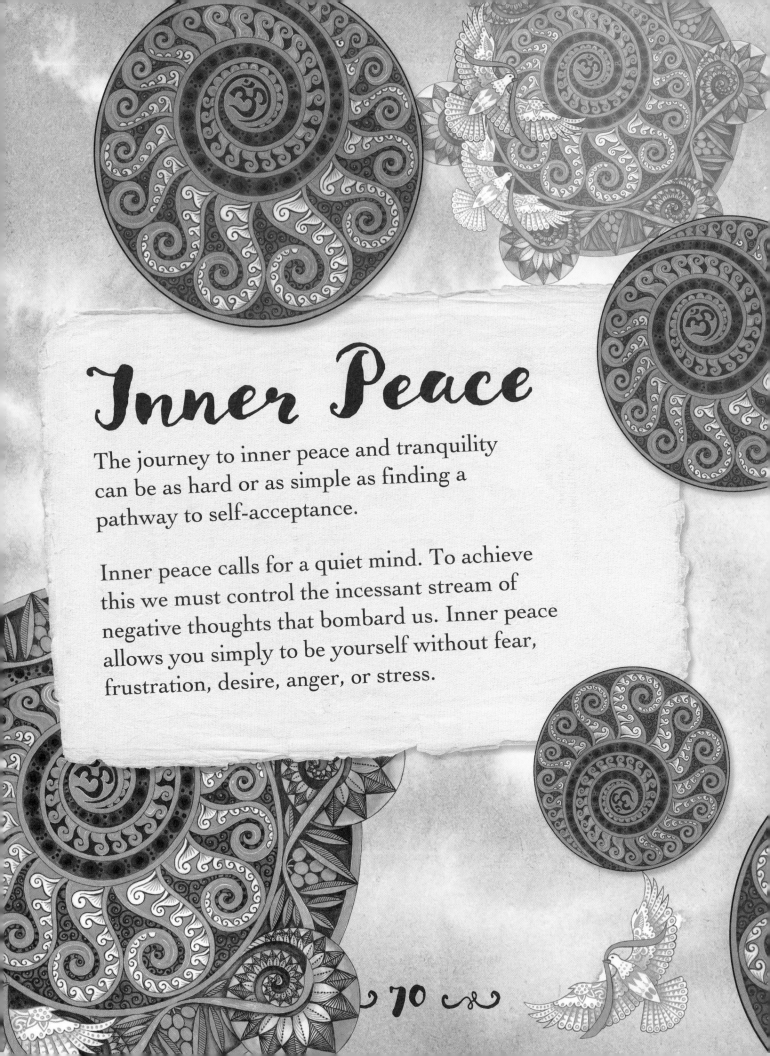

Inner Peace

The journey to inner peace and tranquility can be as hard or as simple as finding a pathway to self-acceptance.

Inner peace calls for a quiet mind. To achieve this we must control the incessant stream of negative thoughts that bombard us. Inner peace allows you simply to be yourself without fear, frustration, desire, anger, or stress.

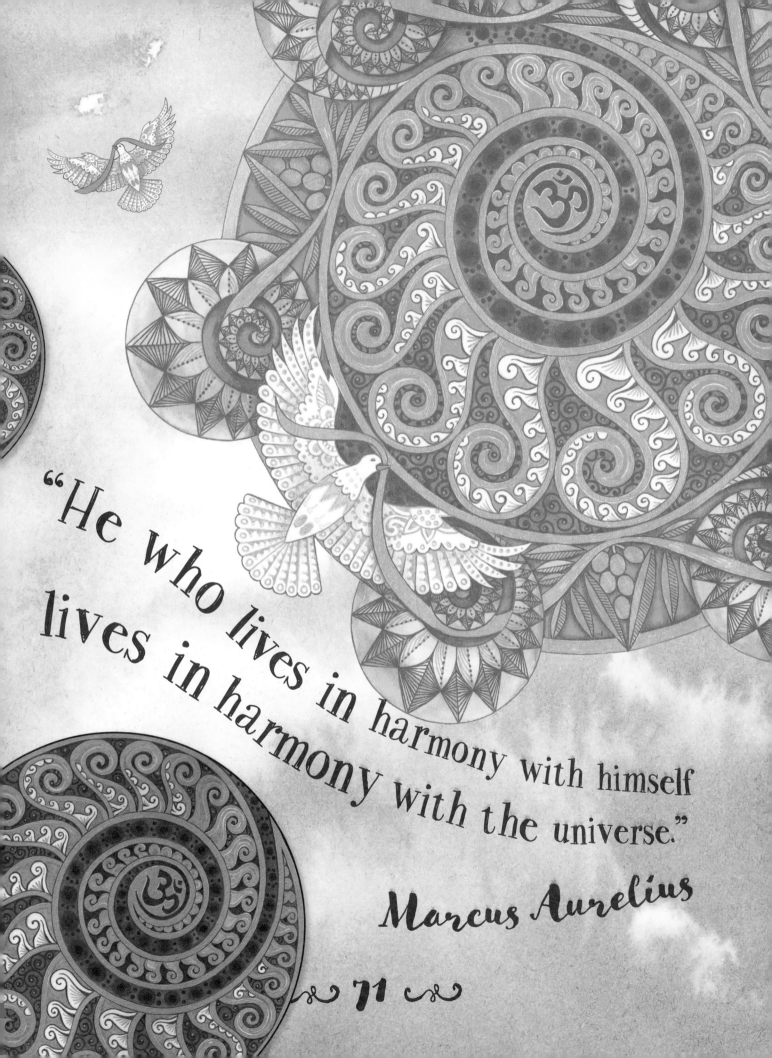

"He who lives in harmony with himself lives in harmony with the universe."

Marcus Aurelius

Peace and Tranquility Collage

Namaste—peace, honor, and respect

Olive branch

A tranquil forest track

Blue flowers symbolizing peace and tranquility

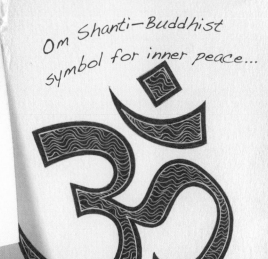

Om shanti shanti shanti:
Buddhist mantra for peace
in mind, body, and spirit

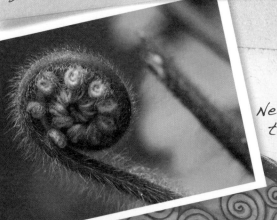

New Zealand tree fern

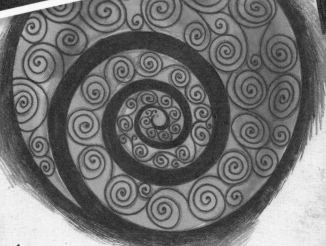

Maori Koru design based on the
spiral shape of a New Zealand
tree fern. It symbolizes peace,
tranquility, and personal growth.

73

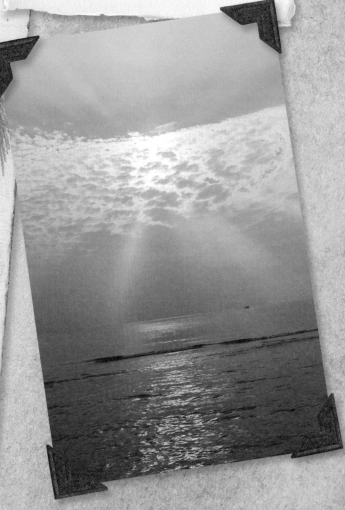

Mandala Design

Emotional Journey

The word *mandala* comes from the Sanscrit language and means "sacred circle." Mandalas have a concentric structure and generally symbolize cosmic and psychic order, wholeness, continuity, and harmony. Each individual mandala has its own unique meaning. When combined with Zen Doodling, creating a mandala can serve as a very powerful tool for one's emotional and spiritual journey.

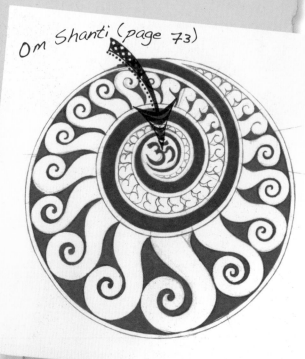

Om Shanti (page 73)

Maori Koru design (page 73)

In the Frame

Start making some rough sketches of your design ideas. Both designs on this page are based on the sweeping shape of a Maori Koru. I have also used the image of a fern frond unfurling as inspiration for Zen Doodling the Koru. The top sketch incorporates an Om Shanti in the center of the spiral. See page 79 for help on drawing spiral shapes.

Develop Ideas

Either develop your first sketches into color roughs, or create more design versions based on the same theme. A dove carrying a ribbon in its beak makes a superb decorative device. Embellish the border by creating a Zen Doodle pattern of olive leaves and berries.

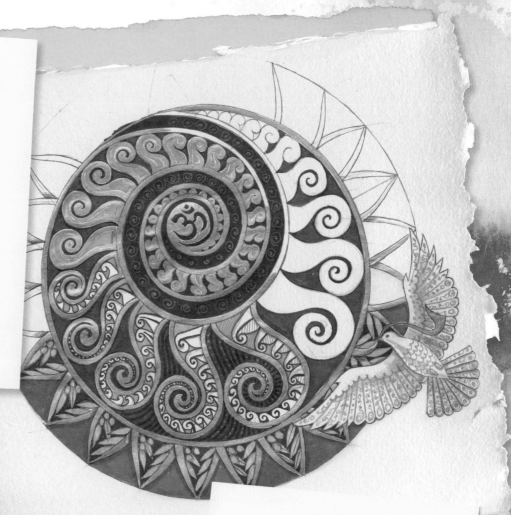

Gilded Effect

Relax and have fun while experimenting with different color schemes. Try adding a gold or bronze border around the shape of the main design. Use different shades of blue, and introduce a rich purple to see if the colors harmonize.

75

Swirling Spirals

Using Compasses

Take a large sheet of smooth watercolor paper and start drawing out your final design. Use compasses to draw the circular shape of the Koru and the surrounding borders. Mark out six points at equal distances apart around the outer border. Then use the compasses to draw six small circles. Make the diameter of each circle the same width as the outer border.

Artist's tip: If you don't have compasses, you can use plates and glasses for the templates.

Draw out one section of the border pattern. Now trace the design onto tracing paper (any thin paper will do). Use the tracing to repeat the design around the rest of the border.

Artist's tip: To draw rounded shapes, start by holding your pencil gently but firmly. Make a series of short overlapping lines to follow the shape of the curve. This method is easier than trying to use a single pencil stroke.

Subtle Background

Now start blocking in the background colors. I painted the main areas of the design with watercolors as they produce beautiful, subtle effects. As an experiment, I painted the six small Korus with clean water first, then carefully added different shades of blue and green watercolors. I let the colors merge, then left the paint to dry.

Mixed Media

Use mixed media to doodle the design. Dark blue and black fineliner pens are ideal for filling in background detail. Use a pale blue-green fineliner pen to color in the olive leaves and fruit. Add depth of color to the watercolor background by adding layers of colored fineliner pen and ballpoint pen hatching.

Peace...

Positive Thoughts

Before you start Zen Doodling, relax your body and take deep, steady breaths. Fill your mind with positive, reaffirming thoughts in order to feel calm, tranquil, and at peace.

Use black fineliner pen to outline the olive leaf design around the border. Then doodle patterns on the leaves.

To contrast with the subtle blue shades of the overall design, use a gold gel pen to color in the central motif and the fern pattern on the large Koru.

Drawing a Spiral

1 Start by drawing a circle. Make a pencil mark in the center.

2 Draw a spiral shape that curves below the center and finishes above it.

3 Add a second spiral shape that runs parallel to the first.

Leaf Pattern

The leaf pattern surrounding the spiral Koru reflects the shape of a fern unfolding. It symbolizes peace, tranquility, and spiritual growth.

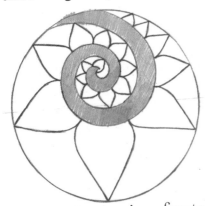

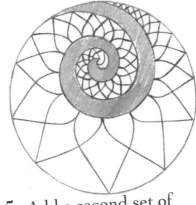

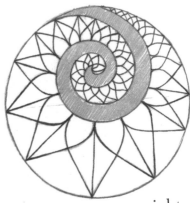

4 Draw in a series of petal shapes around the ever increasing spiral.

5 Add a second set of petal shapes that overlap the first.

6 Now draw a straight line through the center of each petal.

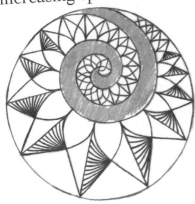

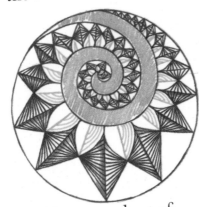

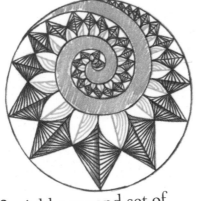

7 Draw in a series of lines that radiate outward (as shown).

8 Add a second set of lines. Now doodle the small petal shapes.

9 Use pale blue fineliner shading to add depth to the doodles. This image shows the finished artwork.

Stay in the Moment

Stay in the moment, focus on what you're doodling and enjoy the creative experience. Finish coloring in the gold gel penwork at the center of the design. Then start Zen Doodling the six small Koru shapes around the border.

Use black fineliner pen to outline the white curl pattern. To increase tonal contrast, add black and gray felt-tip pen spots to the central spiral shape.

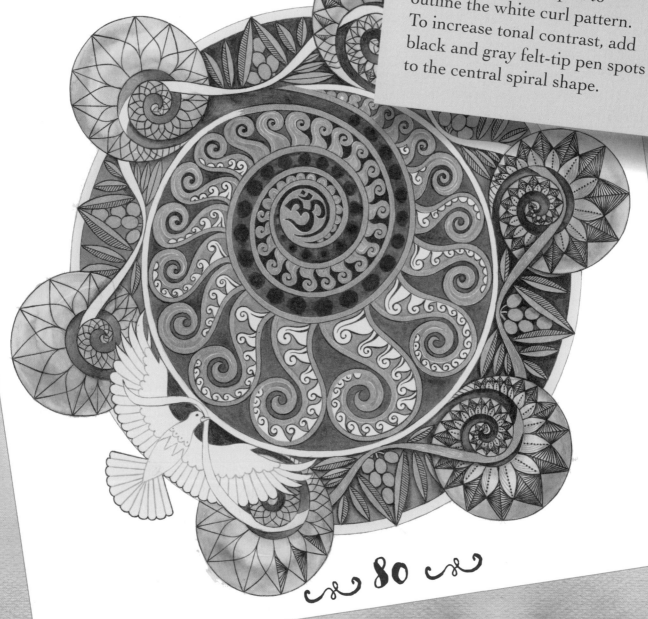

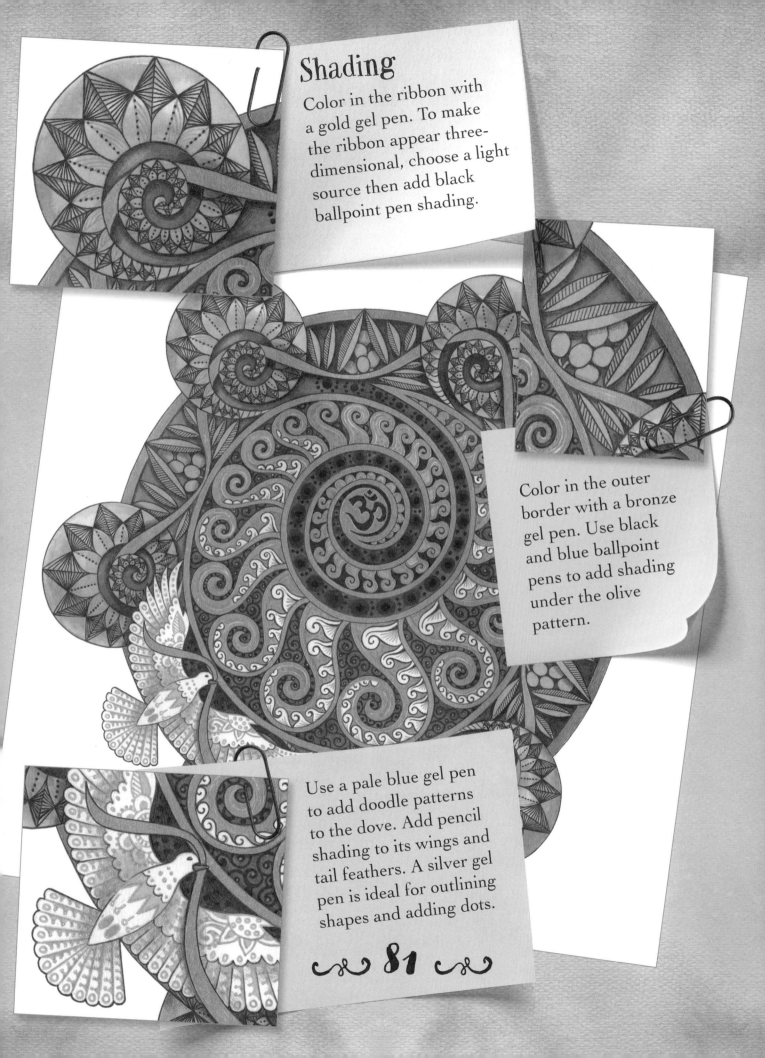

Shading

Color in the ribbon with a gold gel pen. To make the ribbon appear three-dimensional, choose a light source then add black ballpoint pen shading.

Color in the outer border with a bronze gel pen. Use black and blue ballpoint pens to add shading under the olive pattern.

Use a pale blue gel pen to add doodle patterns to the dove. Add pencil shading to its wings and tail feathers. A silver gel pen is ideal for outlining shapes and adding dots.

81

Magical Effect

Watercolor Technique using Salt

Watercolor paint is a wonderful medium to work with. You can create any number of exciting and unexpected textures in your background washes and paintings.

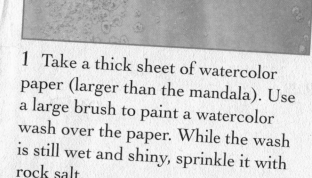

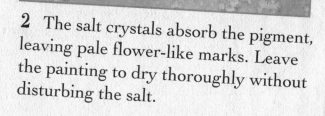

1 Take a thick sheet of watercolor paper (larger than the mandala). Use a large brush to paint a watercolor wash over the paper. While the wash is still wet and shiny, sprinkle it with rock salt.

2 The salt crystals absorb the pigment, leaving pale flower-like marks. Leave the painting to dry thoroughly without disturbing the salt.

3 When the paper is dry, gently brush off the salt crystals. Use the textures as inspiration for Zen Doodling with gold and white gel pens.

4 If the watercolor paper has buckled, lay it out flat, then weight it down and leave it for a few days to flatten again. Finish doodling the background.

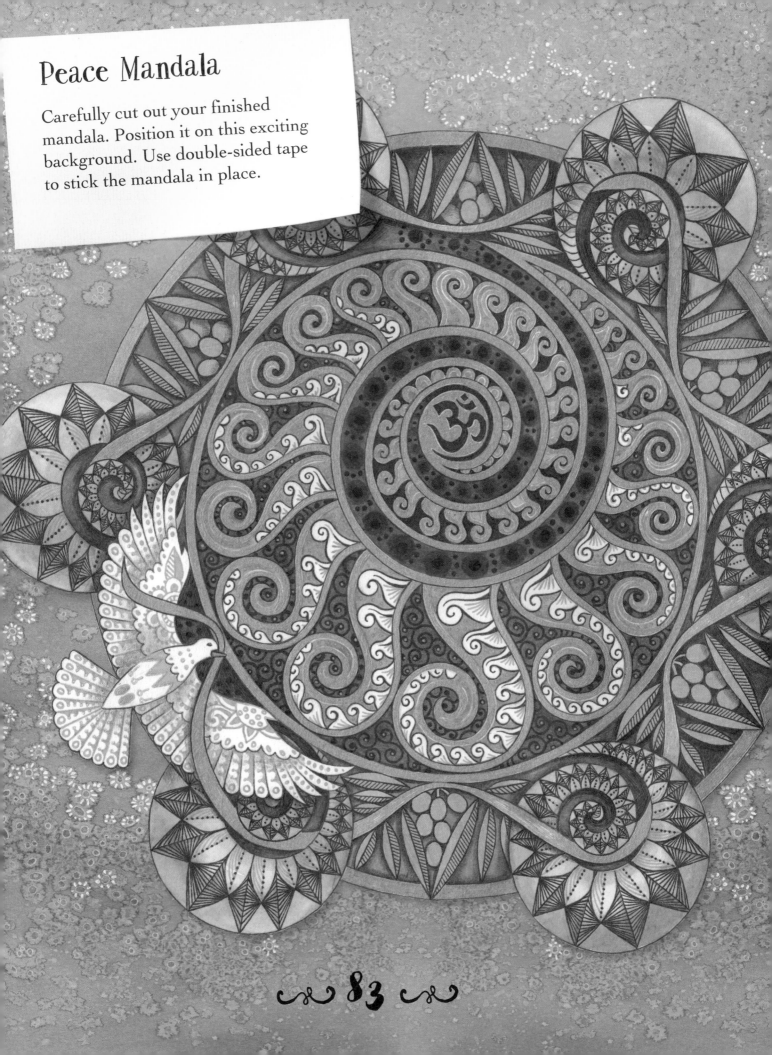

Peace Mandala

Carefully cut out your finished mandala. Position it on this exciting background. Use double-sided tape to stick the mandala in place.

Compassion and

"I have just three things to teach: simplicity, patience, compassion. These three are your greatest treasures."

Lao Tzu

Kindness

Compassion
Compassion in Your Life

Compassion literally means "to suffer together." When you see suffering in others, compassion is the feeling of empathy that leads you to want to care for them.

Being compassionate is beneficial both emotionally and spiritually. It not only helps make us happier, but also brings happiness to those around us. Compassion enables us to see not only another person's point of view, but also to share a part of their emotional journey.

"The more we know, the better we forgive. Those who feel deeply feel for all living beings."

Madame de Stael

Compassion Collage

Red lotus flowers symbolize love and compassion.

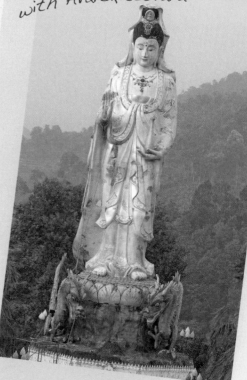

Guan Yin—synonymous with Avalokitesvara

Guan Yin is a spiritual figure from East Asia associated with compassion and mercy.

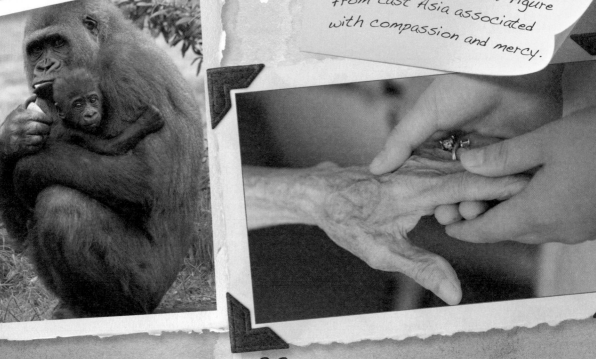

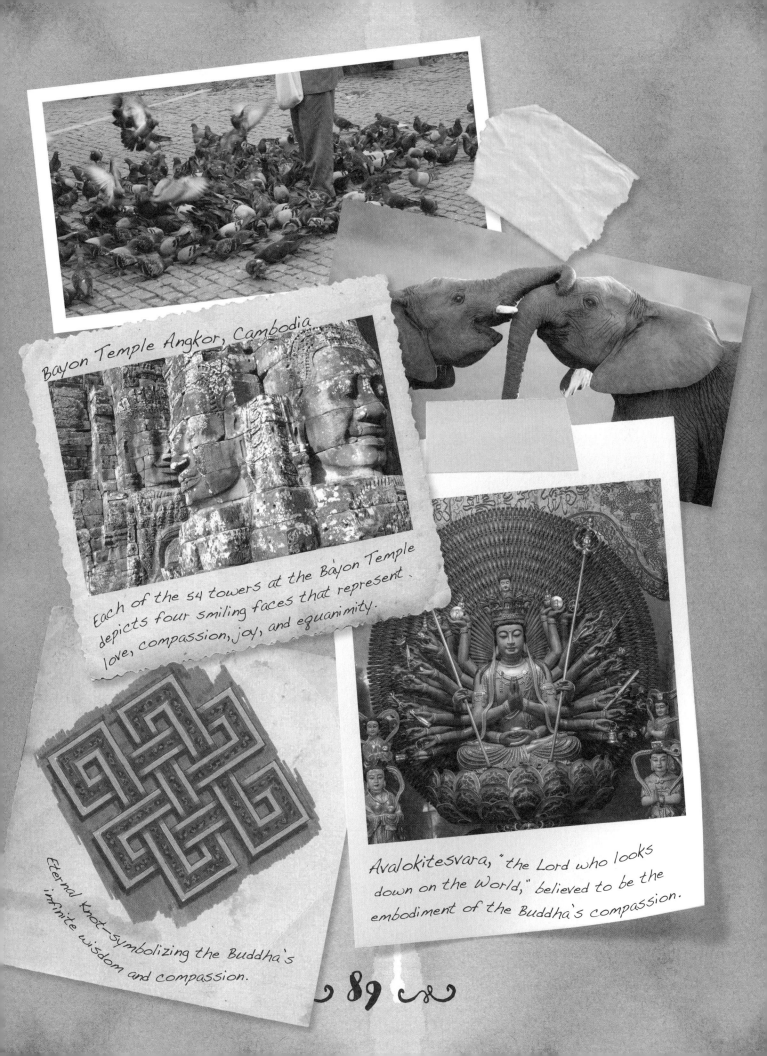

Bayon Temple Angkor, Cambodia

Each of the 54 towers at the Bayon Temple depicts four smiling faces that represent love, compassion, joy, and equanimity.

Eternal Knot—symbolizing the Buddha's infinite wisdom and compassion.

Avalokitesvara, "the Lord who looks down on the World," believed to be the embodiment of the Buddha's compassion.

Mother Nature
Compassion and Nature

Compassion also means love, empathy, and respect for the Earth and all the plants, animals, and microorganisms that support life there. Immersing ourselves in nature allows us to perceive our relationship with the wider world and, in so doing, highlights the importance of care and consideration for our planet and its wildlife.

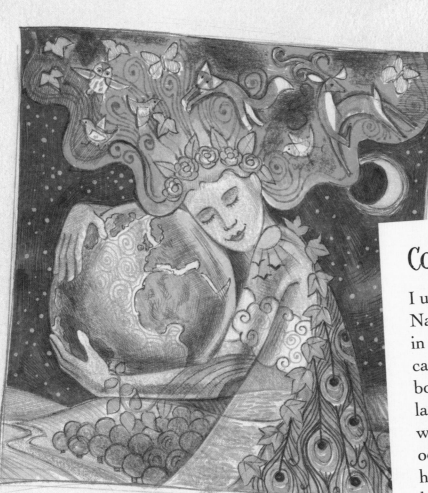

Color Rough

I used the image of Mother Nature cradling the Earth in her arms to symbolize care and compassion. Her body shape blends into the landscape and is decorated with leaves, feathers, the oceans, and sky. Her flowing hair, entwined with animals, balances the composition.

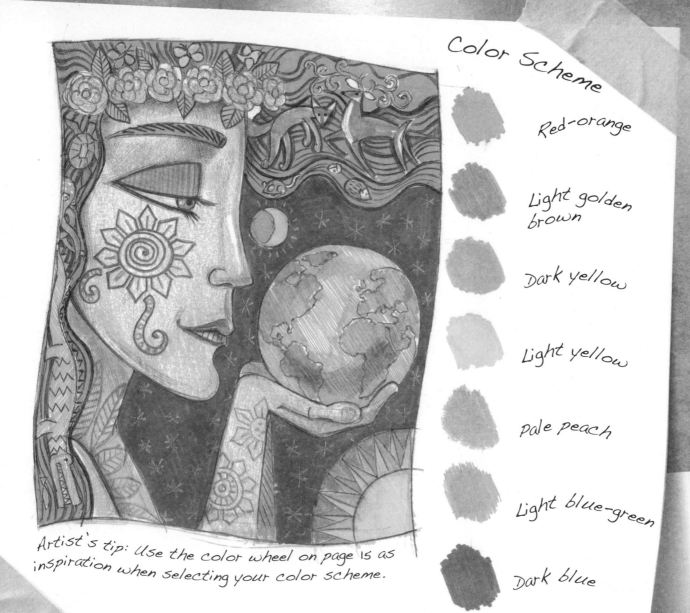

Color Scheme

Red-orange

Light golden brown

Dark yellow

Light yellow

Pale peach

Light blue-green

Dark blue

Artist's tip: Use the color wheel on page 15 as inspiration when selecting your color scheme.

Versions on a Theme

The same color scheme has been used in all three designs. Both color roughs on this page develop the theme of Mother Nature holding the Earth in her cupped hands as she gazes devotedly at the planet. The top rough focuses on her face and hands and uses her hair to frame the image. The other rough shows Mother Nature rooted to Earth, with curling tree branches sprouting from her head.

Indenting
Simple Effective Technique

This simple yet effective technique uses a stylus to deeply indent into the paper. When you lightly shade it with a colored crayon, the indented design shows up as white lines.

Color Rough

Draw your chosen design onto tracing paper or very thin paper. Work on a fairly large scale, as that makes it easier to indent bolder shapes. Lightly trace the design onto thick cartridge paper. Try not to press too hard as you will mark the underlying paper.

Firm Pressure

Artist's tip: Use parallel shading that crosses the direction of the indented lines.

Draw out the design using a "dry" ballpoint pen as a stylus. Press down firmly on the lightly traced lines.

Now relax. Fill your mind with pleasant thoughts of the natural world as you start adding color.

Simplicity

Using a limited palette of colors helps to retain the strength and simplicity of the design. I used gold crayoning for Mother Nature's face and hands and added a thin gold frame to hold the image together.

Tonal Contrast

Adding Depth

The finished colored design lacks tonal contrast. However, this can easily be adjusted by adding shading to specific areas and some bold Zen Doodling.

Artist's tip:
To check tonal contrast, place the artwork at a distance. Squint at the image. If there are no definite light or dark areas, the picture will be flat and lack depth.

Light Source

Although the sun features in the design, I thought it would be more effective to place the light source above the image and slightly to the right. To create the 3D effect, I used dark orange and brown fineliner pens to add shading beneath the animals.

Light source

Zen Doodling

Gold and bronze gel pens are ideal for doodling on top of textured crayoning. Use a black 0.5 mm fineliner pen to finish Mother Nature's eyelashes and to add further detail to the design.

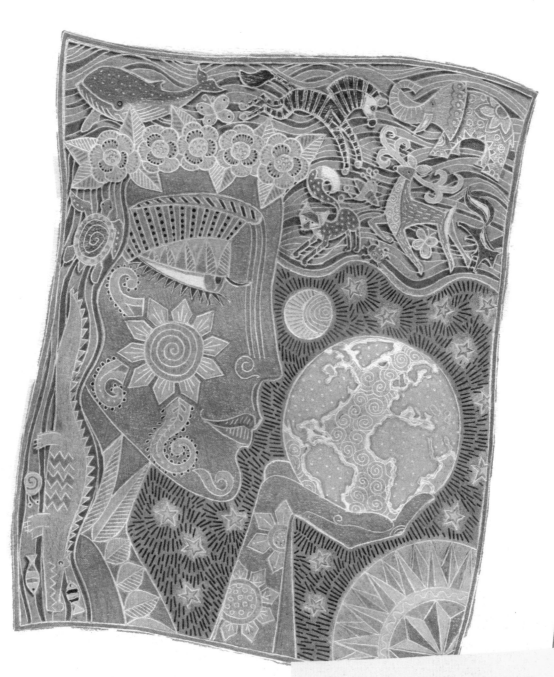

Decorate

Use dark brown fineliner pen to add darker tones to Mother Nature's hair. Finish her face with bronze gel pen outlines. Finally, doodle the sky with black fineliner pen lines.

Lotus Flower

Focus Attention

After completing the "Mother Nature" artwork, I felt that it needed framing. A frame focuses attention on an image and adds a finishing touch that completes the artwork. I chose to use a wide, dark frame to contrast with the delicate pastel shades of the picture.

Artist's tip: Draw out one quarter of the design only onto tracing or thin paper. Then turn, flip over, and retrace to create the rest of the frame pattern.

Large Scale

You will need a large sheet of thick black paper. Use a ruler and pencil to draw the frame for your picture.

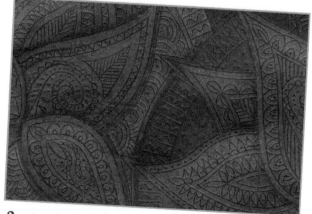

1 Design a bold lotus flower pattern for the frame. Trace it out.

2 Indent the paper with your design. Crayon over the pattern.

3 Make the pattern look 3D by adding black pencil crayon shading.

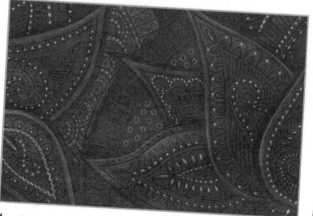

4 Highlight with a gold pencil crayon. Add gold gel-pen doodles.

Buddhist Symbol

In Buddhism, a red lotus flower symbolizes compassion, love, and passion. It is the flower of Avalokitesvara, the legendary Buddhist figure who vowed to help free all living things from suffering.

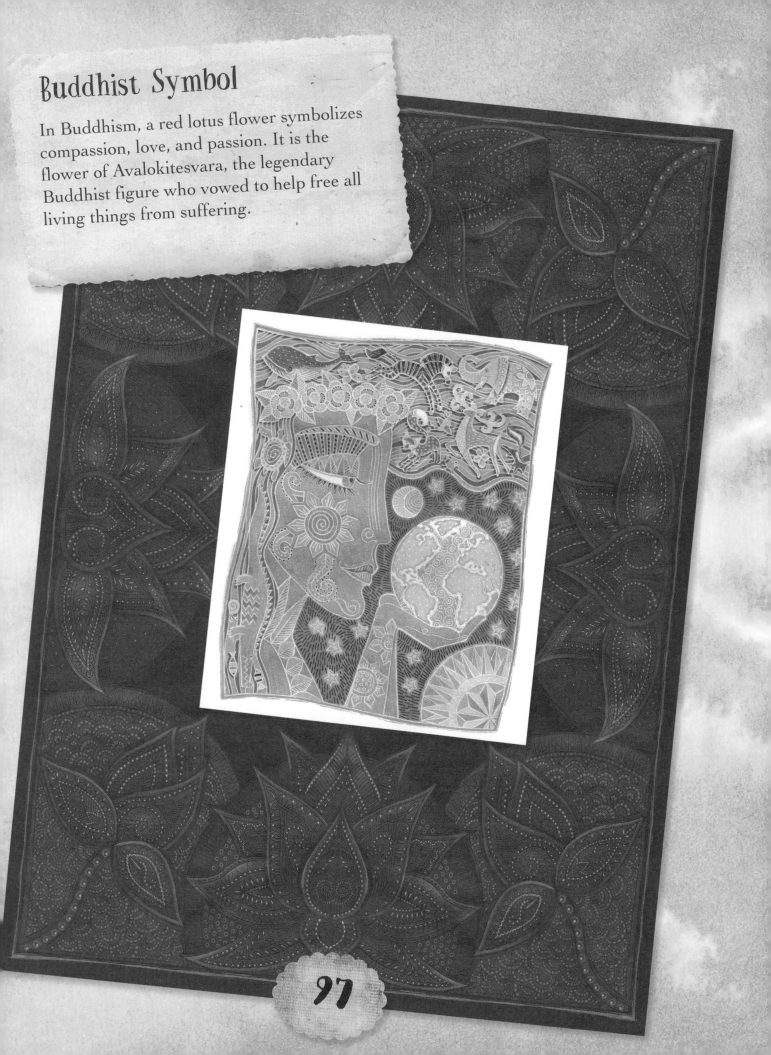

Joy and

"Joy descends gently upon us like the evening dew, and does not patter down like a hailstorm."

Jean Paul

Happiness

Joy and Happiness

Happiness means different things to many people. It is generally considered that happiness is a feeling of well-being, accompanied by emotions that range from intense pleasure through to contentment and satisfaction. Happiness tends to be a temporary state, whereas joy is consistent and lasting. Happiness is external; it is dependent on our circumstances and can be aroused simply by buying something we want.

Joy comes from within. It happens when we learn to appreciate life, our relationships with other people, nature, or perhaps our personal spirituality. Joy is a stronger, less common feeling and results in deep, inner peace and contentment that can be sustained through periods of difficulty and stress.

"Happiness is a gift and the trick is not to expect it, but to delight in it when it comes."

Charles Dickens

Collage of Symbols Representing Joy and Happiness

Sunflowers

Bluebird

Marjoram

Chinese symbol of double happiness

Bat

Hummingbird

Fish

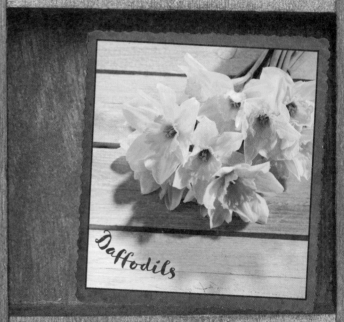

Daffodils

Dolphins

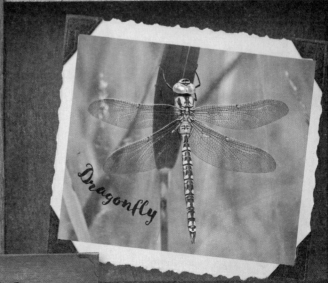

Dragonfly

Symbolism
Different Meanings

SUNFLOWERS are seen as "happy" flowers. They symbolize happiness, optimism, honesty, faith, and adoration.

BLUEBIRDS are likened to heavenly messengers bringing joy and peace. They symbolize happiness in many cultures.

MARJORAM represents happiness, peace, and harmony. According to mythology, the Goddess Aphrodite created sweet marjoram as a symbol of happiness.

DOUBLE HAPPINESS is a Chinese symbol or character used as decoration and as a symbol of marriage.

BATS are a symbol of happiness and good fortune in China. Elsewhere, they can also symbolize rebirth, intuition, and communication.

HUMMINGBIRDS are believed to symbolize joy and happiness, beauty and harmony. They also represent determination and adaptability.

FISH are Buddhist symbols of happiness and freedom. In other cultures, they represent eternity, creativity, and knowledge.

DAFFODILS are associated with joy and happiness in Japan. In other cultures, they signify vitality, renewal, and forgiveness.

DOLPHINS symbolize happiness, playfulness, peace, and harmony, as well as inner strength and resurrection.

DRAGONFLIES symbolize the entire emotional world including joy and happiness. They symbolize transformation because of their incredible lifecycle.

Combine the Images

I wanted to combine all these diverse symbols in such a way as to create a beautiful, harmonious image. My initial idea was to take a sunflower and a hummingbird as the central motif, then add a pattern around the edges using a selection of the other symbols.

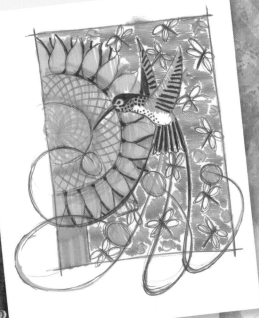

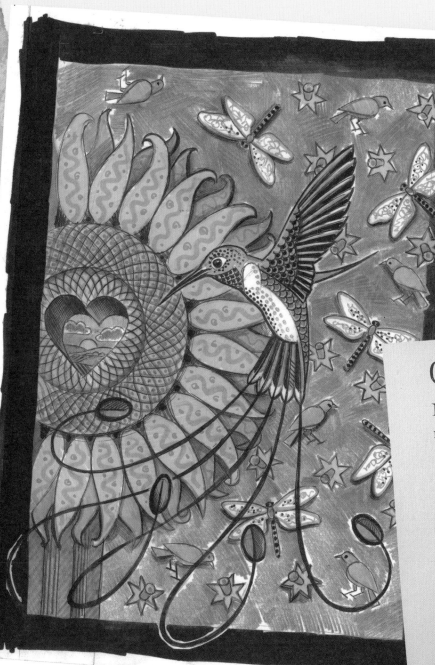

Start by making a thumbnail sketch (above) of your composition.

Color Rough

Now create a large color rough of your design. Sketch in the sunflower and hummingbird first. Then draw a small dragonfly, a daffodil, and a bluebird onto a sheet of tracing paper. Trace these images onto the background to create a random pattern. Block in the background with gold. Finish coloring in the design. Add shading under the images to create a 3D effect.

Joyful Colors
Dynamic Design

I wanted to try another composition using additional symbols. This new dynamic design has a curved shape running diagonally through it with a contrasting gold and black background.

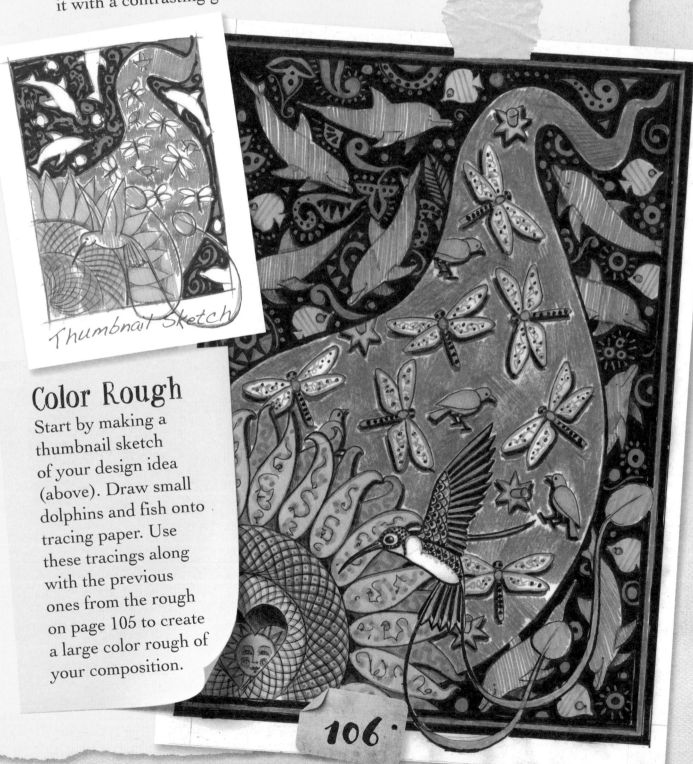

Thumbnail Sketch

Color Rough

Start by making a thumbnail sketch of your design idea (above). Draw small dolphins and fish onto tracing paper. Use these tracings along with the previous ones from the rough on page 105 to create a large color rough of your composition.

Face of the Sunflower
Pattern Deconstruction

A sunflower's incredible face is made up of a complex pattern of spirals. It is easy to draw if you deconstruct the pattern into these simple steps:

1 Use compasses to draw two concentric circles for the sunflower's face. Mark the center, then draw in a heart shape.

2 Pencil in a series of equally spaced, long thin reverse "S" shapes between the two circles.

3 Pencil in a second series of "S" shaped lines in the opposite direction across the first lines.

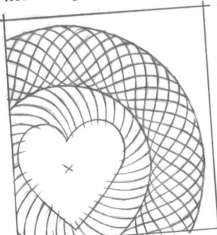

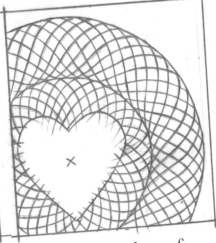

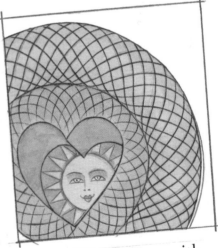

4 On the inner circle, pencil in a series of parallel lines that curve into the central heart shape.

5 Add a second set of curved lines that cross over the first set in the opposite direction.

6 Go over the lines with black ink. Erase any pencil lines. Add a smiling sun to the heart shape. Add watercolor washes.

Doodling

Trace and Color

Trace out your finished color rough onto a thick sheet of smooth watercolor paper. Refer to page 107 to deconstruct the pattern of the sunflower's face. Use pale watercolor washes to color in the main elements of your design. Block in the background of the dolphins and fish with orange watercolor paint or felt-tip pen.

Associations...

Use the colors you associate with joy and happiness. Yellow, orange, and gold are the colors of sunshine, warmth, optimism, and passion. Add blue and green—colors associated with peace and tranquility.

Outline

Go over your pencil outlines with a black ballpoint pen. See Artist's tip (opposite) for advice on drawing fluid, curved lines. Erase any pencil marks.

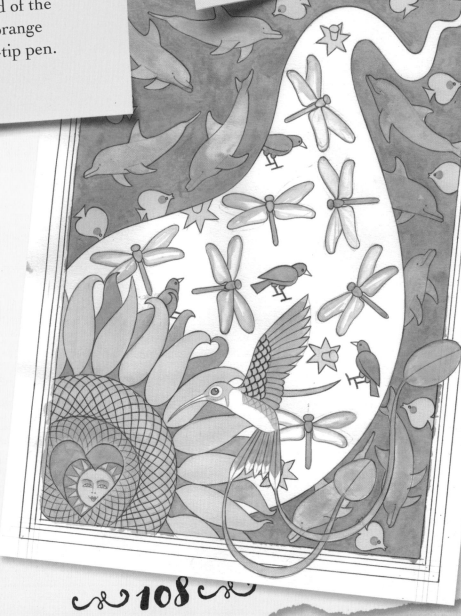

Now relax, fill your mind with happy memories, and immerse yourself in the joys of Zen Doodling!

Build Up

Use fineliner pens and fine-nibbed felt-tip pens to doodle patterns on the sunflower. Zen Doodle the dragonflies, birds, and daffodils. Use a fluorescent green marker pen to color in the hummingbird's face and wing before doodling with felt-tip pens and a black fineliner pen. Outline the dolphins, fish, and the large white shape with a black marker pen. Pencil in doodled patterns on the orange background, then doodle in with black fineliner pens.

Richness
Depth and Contrast

Add a bold, black shadow below the dragonflies, birds, and daffodils to make them stand out and to create a 3D effect. Add shadows under the sunflower petals, too.

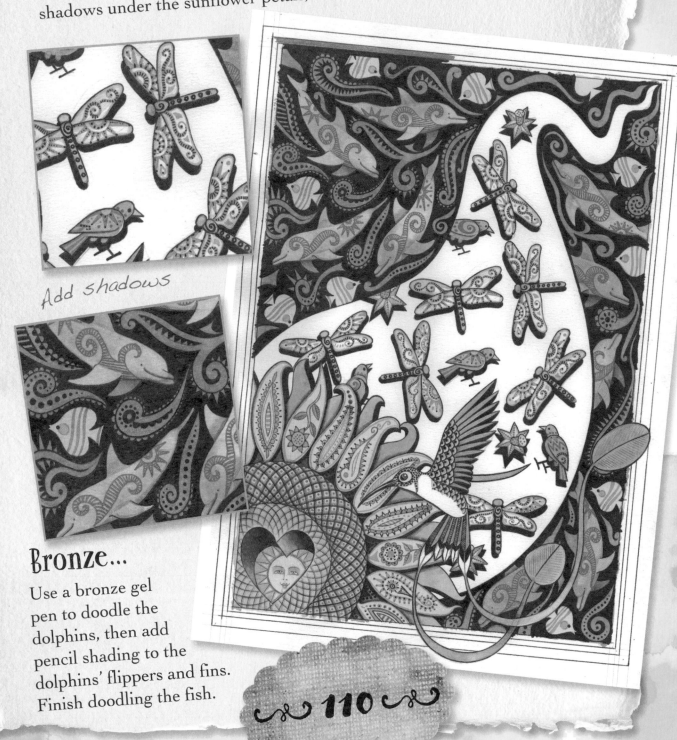

Add shadows

Bronze...

Use a bronze gel pen to doodle the dolphins, then add pencil shading to the dolphins' flippers and fins. Finish doodling the fish.

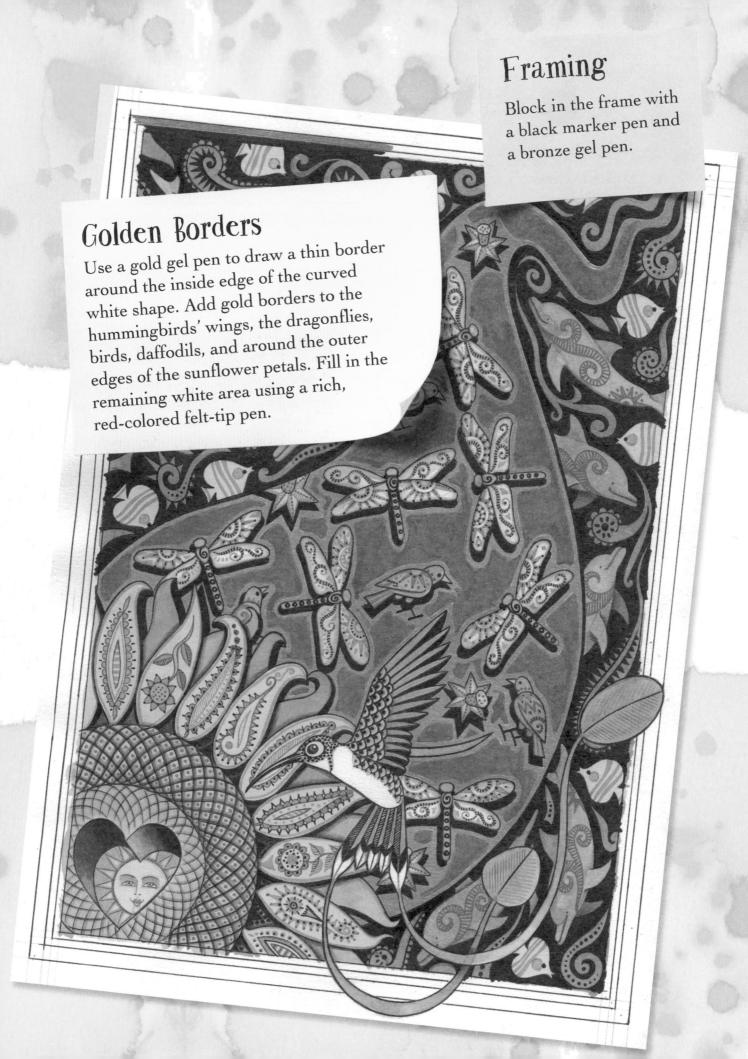

Framing

Block in the frame with a black marker pen and a bronze gel pen.

Golden Borders

Use a gold gel pen to draw a thin border around the inside edge of the curved white shape. Add gold borders to the hummingbirds' wings, the dragonflies, birds, daffodils, and around the outer edges of the sunflower petals. Fill in the remaining white area using a rich, red-colored felt-tip pen.

Golden
Gilding Paper

This exciting technique produces a richer, more vibrant effect than gold paint. A fine layer of gold leaf is applied to a paper surface that has been brushed with a thin coat of glue.

You Will Need:
- Gold flakes (from most art shops)
- PVA glue or gilding medium
- Fine paintbrush
- White spirit to clean brush
- Thick soft paintbrush
- Spoon or other rounded object

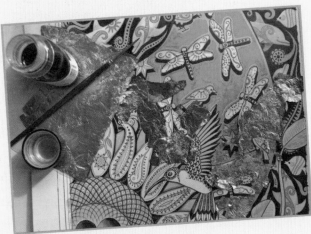

1 Use a fine paintbrush to paint on the gilding medium or glue, working on small areas of the background at a time. Once the glue feels tacky, carefully start laying on pieces of gold flake.

2 Gently tamp down the gold flakes using a large, soft paintbrush. Lay a clean sheet of thin paper over the top, then burnish the paper surface with the back of a spoon or a similar object.

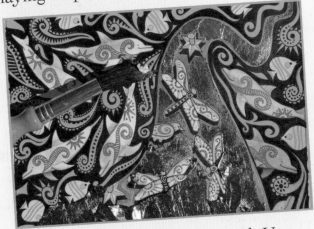

3 Finish gilding the background. Use the large paintbrush to gently brush off any excess gold flakes.

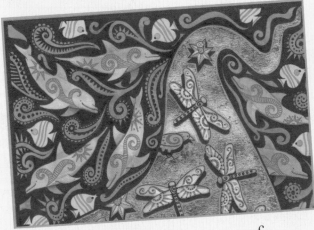

4 Fill in any gaps with scraps of gold leaf. Let spots of red paint show through in places for added interest.

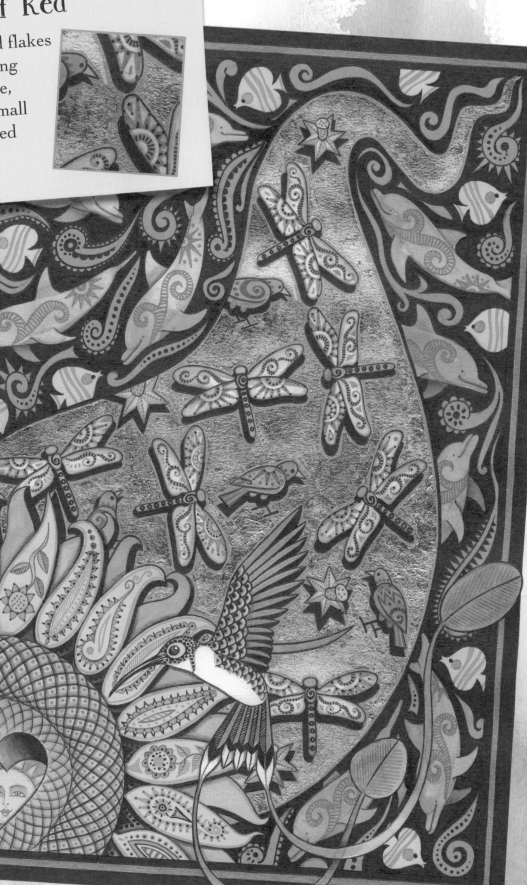

Flashes of Red

The fragile gold flakes create an exciting crinkled texture, enlivened by small specks of the red undercoat.

Journey of the Emotions

Kindness

LOVE

Compassion

LOVE

Tranquility

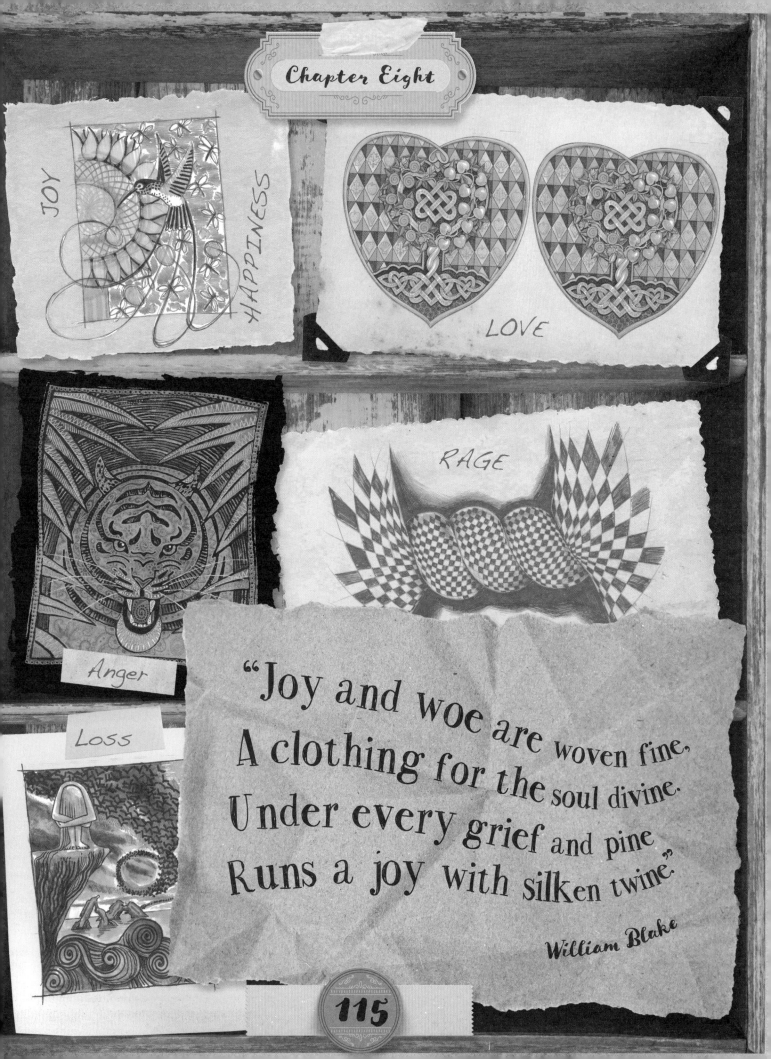

JOY

HAPPINESS

LOVE

RAGE

Anger

Loss

"Joy and woe are woven fine,
A clothing for the soul divine.
Under every grief and pine
Runs a joy with silken twine."

William Blake

An Emotional Journey

In our journey through life, we encounter a range of powerful emotions. Many emotions are pleasurable but others can be frightening and distressing. Emotions can be likened to a river that needs to flow freely. By suppressing your feelings, you stem your internal energy, and this can lead to stress.

Let your mind wander and picture all the things, people, and places that mean the most to you. The positive feelings we get from enjoying the beauty of nature, listening to music, or getting lost in a painting can be uplifting and help our physical well-being.

"The artist is like a divining rod, seeking emotions from the world around: from the natural environment, from random objects and life itself."

Max Marlborough

Collage of Inner Reflection

Create a collage from a selection of images that have a special meaning for you. My images reflect a love of artistic creativity and books, and include my passion for nature and the undersea world.

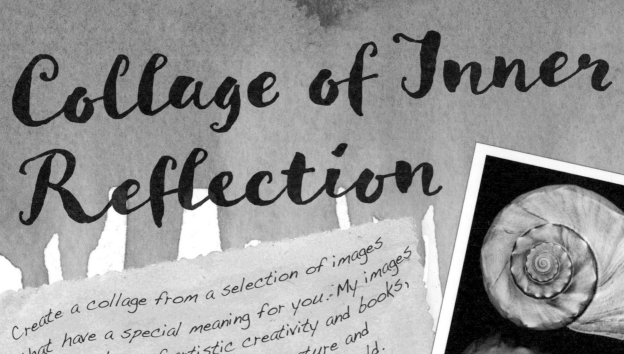

Winding Road

Free Your Mind

A winding road makes a wonderful metaphor for the journey through one's emotional life. Use the curved lines of the image as the basis for a composition that reflects your personal passions, both real and imaginary.

Thumbnail Sketch

Start by making one or more thumbnail sketches of your composition.

Finished Sketch

Free your mind and draw whatever your imagination conjures. Make a finished sketch of your composition. I used swirling shapes to divide the picture up into sections—one for favorite things, another for fantasy…

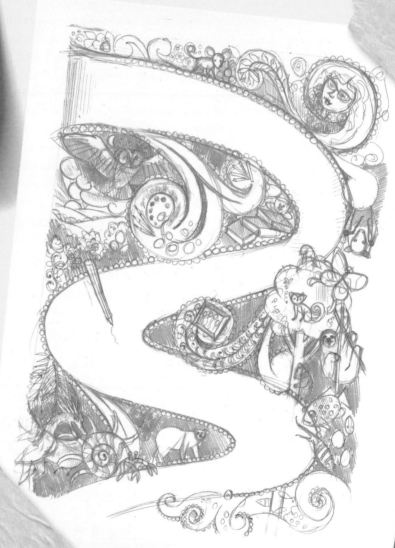

Finished Design

Redraw your design onto thick cartridge paper. Take the opportunity to change and adapt any parts of the composition that you have doubts about. Once you have finished penciling in, relax, let your mind wander, and start Zen Doodling...

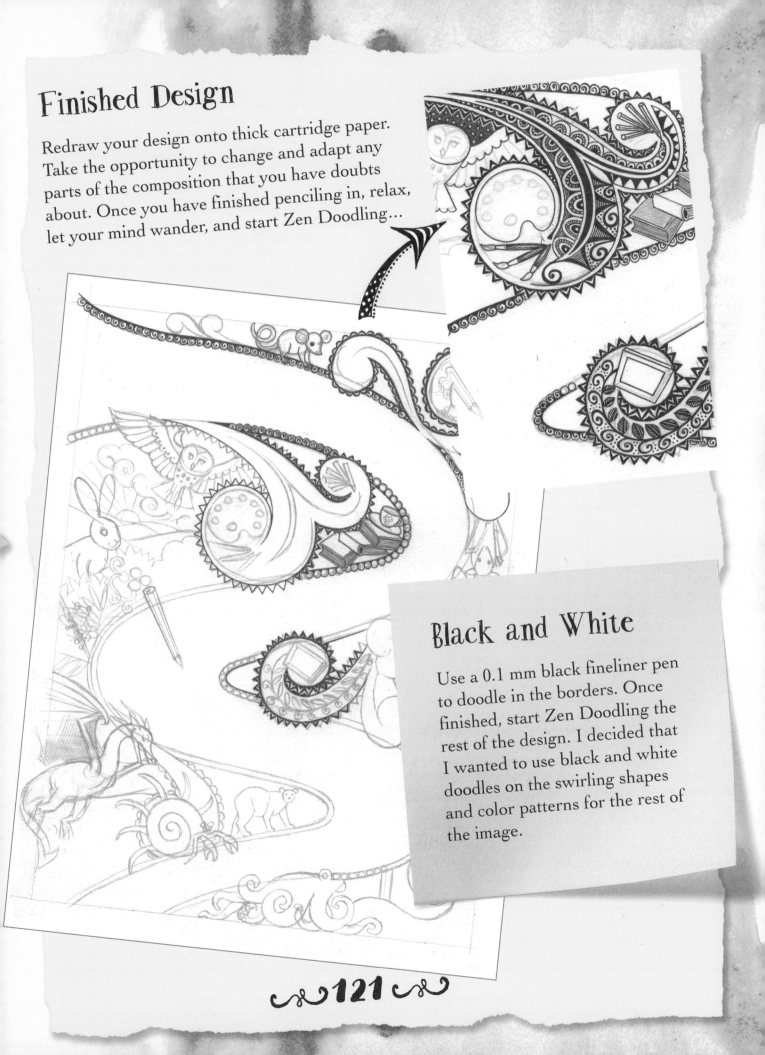

Black and White

Use a 0.1 mm black fineliner pen to doodle in the borders. Once finished, start Zen Doodling the rest of the design. I decided that I wanted to use black and white doodles on the swirling shapes and color patterns for the rest of the image.

Color Scheme

Color Temperature

Warm colors such as yellow, orange, and red reflect warmth, energy, or heat. Cool colors such as blue, green, and turquoise imply peace, coolness, or stillness. A single color can also have different color temperatures; for example, blue can be warmer or colder.

Selected Areas

Try using different color schemes for selected areas of your composition. Start by Zen Doodling the top section in light brown fineliner pen with gold and silver gel pens.

Cool Colors

Blue-purple

Navy blue

Light blue

Turquoise

Green

Blue-green

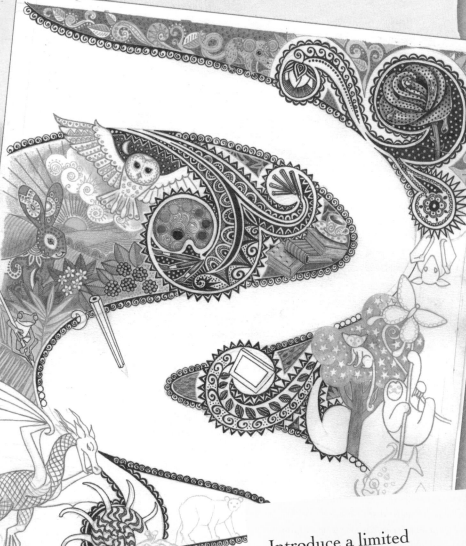

Introduce a limited palette of colder colors as you doodle your way down the design.

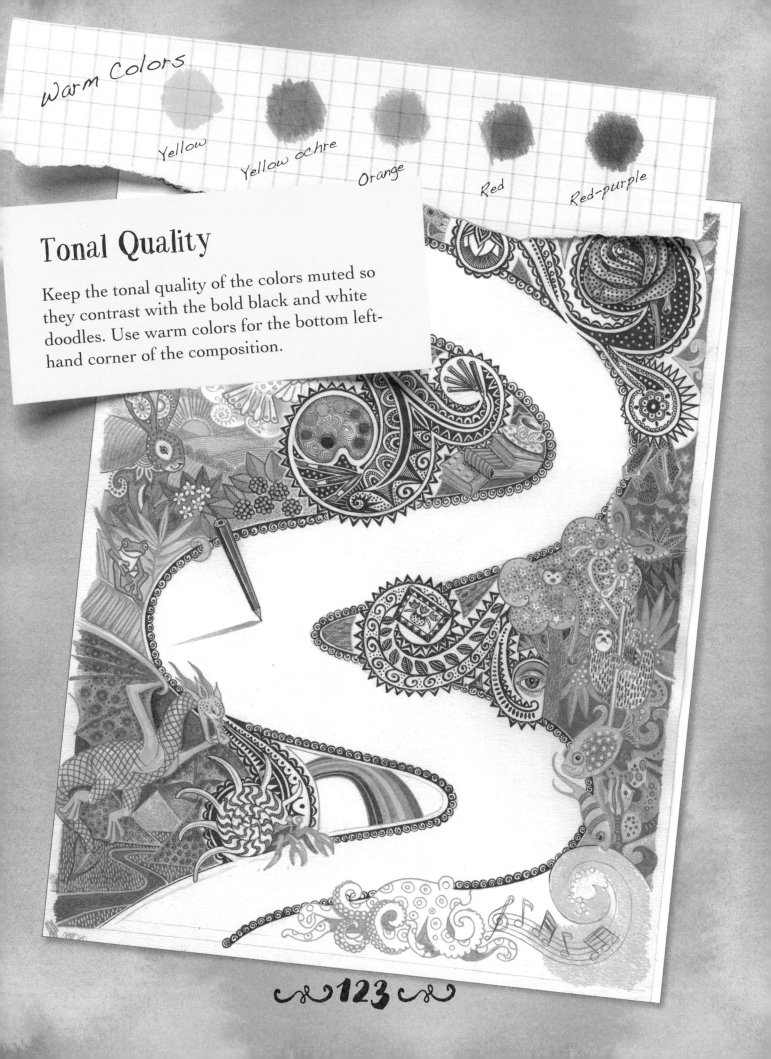

Warm Colors

Yellow

Yellow ochre

Orange

Red

Red-purple

Tonal Quality

Keep the tonal quality of the colors muted so they contrast with the bold black and white doodles. Use warm colors for the bottom left-hand corner of the composition.

Finishing Touches

Emotive Words

A nice finishing touch for your artwork is to add emotive words that follow the direction of your journey's path. The easiest way to do this is to write the words by hand. Alternatively, you can cut out lettering from old magazines, arrange them into words, then stick them onto your picture. You can also buy rub-down lettering from specialist suppliers, which is easy to use and very effective.

Gold on Black

Use double-sided tape to mount the artwork onto a sheet of white cartridge paper. Trim the picture, leaving a thin white border around the image. Now take a sheet of thick black paper or cardboard and, using a ruler, draw a rectangle the same size as the image. Draw a frame around the outside edges.

Simple Frame

I wanted the frame to reflect the personal intimacy of the artwork in order to draw in the viewer and encourage him or her to explore the picture. A thin black frame contains the image and creates dramatic contrast, too.

1 Lightly pencil in a pattern on the frame based on the black and white swirling shapes in the picture. Use a gold gel pen to Zen Doodle the design.

2 Finish the frame with bronze gel pen doodles. Use double-sided tape to mount the artwork onto the completed frame.

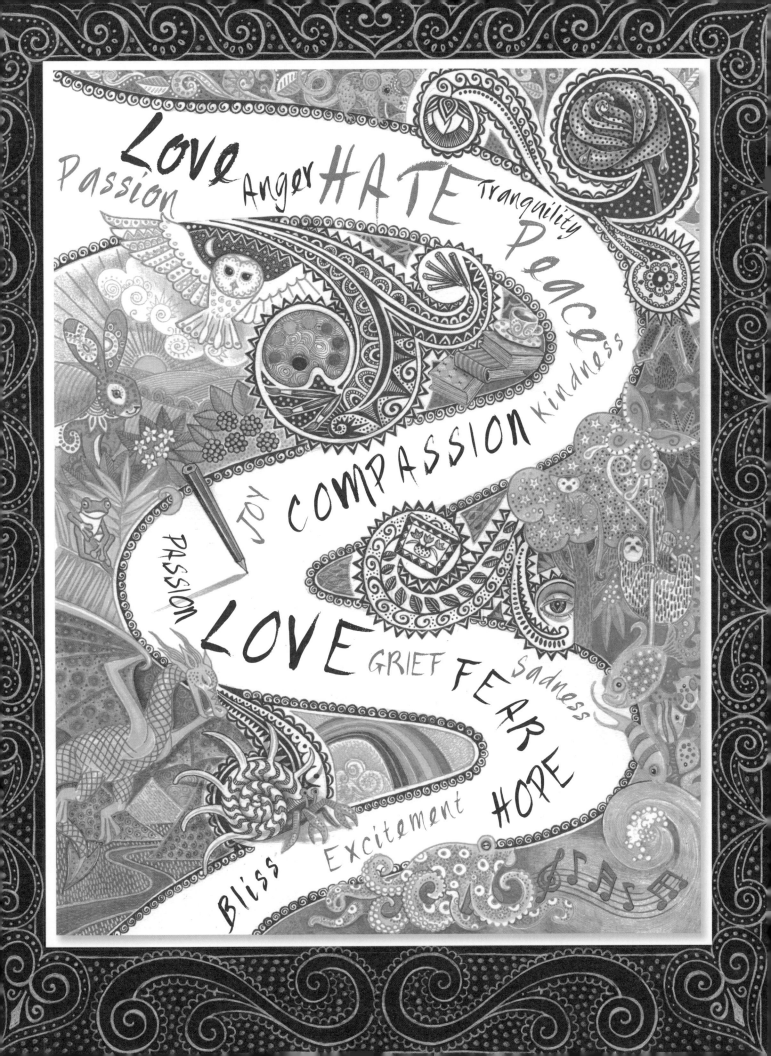

Glossary

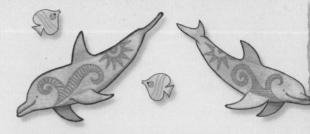

Analogous colors Harmonious colors that lie next to each other on the color wheel (page 15).

Burnish To make something smooth and shiny by rubbing it.

Cathartic Providing emotional release.

Collage Artwork made by gluing things to a surface.

Color temperature The coolness or warmth of a color (blue-green is coolest and red-orange is warmest).

Compass Instrument for drawing circles and arcs.

Complementary colors Colors that lie opposite each other on the color wheel (page 15). Used side by side, they convey energy and excitement.

Composition The arrangement of the main parts of a design in order to form a unified whole.

Cross-hatching A shading technique using two or more sets of intersecting parallel lines.

3D Having, or seeming to have, the three dimensions of depth, width, and height.

Deconstruction Breaking down a pattern into simple components.

Design A graphic representation, usually a drawing or a sketch.

German Expressionism An artistic style in which the artist depicts the subjective emotions and responses that objects and events arouse in him rather than those represented in physical reality.

Gilding A decorative technique for applying gold leaf to a surface.

Gold leaf Gold in the form of a very thin layer of foil.

Hatching A shading technique using a series of parallel lines.

High Renaissance An artistic style developed in Italy in the late 15th and early 16th centuries.

Indenting The use of a blunt instrument to indent lines on paper, which show as white lines once crayoned.

Light source The direction from which light originates.

Limited palette A restricted number of colors used in artwork.

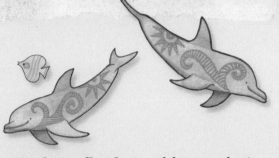

Masking fluid A rubbery solution used to mask out areas of paper to isolate them from applications.

Meditation The act of spending time in quiet thought.

Metaphorical A visual image that suggests a particular association or point of similarity between it and a person, place, thing, or idea.

Mindfulness The focusing of one's awareness on the present while acknowledging one's feelings and sensations.

Optical illusions Images that we perceive differently. They occur when our eyes send information to our brain that tricks us into perceiving something that does not match reality.

Post-impressionism An artistic movement with an emphasis on abstract qualities or symbolic content.

Primary colors The three colors (red, yellow, and blue) from which all other colors can be mixed.

Secondary colors The colors that are made by mixing the three primary colors.

Shading The marks an artist uses to represent gradations of tone.

Stylus A small tool for marking or engraving.

Subconscious The part of the mind that a person is not fully aware of but which influences their actions and feelings.

Symbolism The depiction of something using symbols or giving symbolic meaning to something.

Symmetrical Balanced, with each half (of a design) reflecting the other.

Tertiary colors The colors that are formed by mixing a primary and a secondary color.

Thumbnail sketch A small rough sketch that is quickly executed.

Tonal contrast The difference between the lightest and darkest parts of an image.

Watercolor wash A layer of diluted watercolor painted onto paper.

Wax resist The use of wax marks to prevent water-based paint reaching specific areas.

Index